SPECIAL COLLECTIONS

THE PHOTOGRAPHIC ORDER FROM POP TO NOW

BY CHARLES STAINBACK

Publication of the catalogue was made possible by
The Robert Mapplethorpe Foundation.

This exhibition is made possible by a grant from
the New York State Council on the Arts and assisted by grants from the Merlin Foundation and Christie Sherman.

INTERNATIONAL CENTER OF PHOTOGRAPHY
New York City, 1992

Library of Congress Cataloging-in-Publication Data

Special Collections: the photographic order from pop to now / an exhibition organized by Charles Stainback.

p. cm.

ISBN 0-933286-62-7 — ISSN 0163-7916

1. Art and photography—History—20th century—Exhibitions.

2. Art, Modern—20th Century—Themes, motives—Exhibitions.

I. Stainback, Charles, 1952- . II. International Center of Photography

N72.P5S64 1992

779'.97'00904507473—dc20

92-25596

CIP

r92

Distributed by: D.A.P./Distributed Art Publishers

636 Broadway, Room 1208

New York, NY 10012

Tel 800-338-BOOK Fax 212-673-2887

SPECIAL COLLECTIONS

THE PHOTOGRAPHIC ORDER FROM POP TO NOW

DENNIS ADAMS

JOHN BALDESSARI

BERND & HILLA BECHER

CHRISTIAN BOLTANSKI

SARAH CHARLESWORTH

SUSAN EDER

JUDY FISKIN

ROBBERT FLICK

ROBERT HEINECKEN

RICK HOCK

DOUGLAS HUEBLER

ALLAN KAPROW

LOUISE LAWLER

SOL LEWITT

ARNAUD MAGGS

ANNETTE MESSAGER

RAY METZKER

GARRY FABIAN MILLER

RICHARD PRINCE

ALAN RATH

EDWARD RUSCHA

MITCHELL SYROP

ANDY WARHOL

ROBERT WATTS

NEIL WINOKUR

Special Collections:
The Photographic Order From Pop to Now

*It matters much with what and in what order each
element is set.*
 —Lucretius (c. 99 to 50 B.C.)[1]

You can observe a lot just by watchin'.
 —Yogi Berra (1963)[2]

In 1936 renowned author and critic Walter Benjamin suggested in his seminal essay *The Work of Art in the Age of Mechanical Reproduction* that it was "futile" to question whether photography was art, but deemed the central issue to be "whether the very invention of photography had not transformed the entire nature of art."[3] While Benjamin's suggestion helped manifest some of these very transformations, it was not until the dynamic changes of the early 1960s that photography was indeed seen as transforming the arts—not only through the increasing utilization of the photograph by artists of all fields but also with the expanded definition of the medium of photography by photographers themselves.

The artists in *Special Collections* trace the shift in photography's role in the arts in the years "from Pop to Now." What these artists share is an interest in constructing artworks that catalogue, classify, archive, and order numerous photographic elements into a complete, unified piece. Rejecting Henri Cartier-Bresson's notion of the "decisive moment," wherein a perfectly constructed composition is captured in a single frame, these artists have created works ranging from a few architectural images in multi-part displays to more than seven thousand portraits in a single artwork. These developments paralleled the Modernist "gestalt"

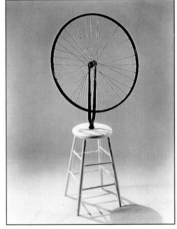

MARCEL DUCHAMP
Bicycle Wheel – Ready Made, 1964
Philadelphia Museum of Art: Given by Schwartz Galleria d'Arte

of the art object to the Postmodernist "reading" of the art object as a text. In the thirty years from Pop to the present—from Andy Warhol's first photo-silkscreen paintings in 1962 of the "borrowed" news photo to Conceptual artist Douglas Huebler's project "to photograph the existence of everyone alive" to Postmodern artist Richard Prince's "gangs"[4] produced in the 1980s—the traditional presentation of the photograph (the 8 x 10 glossy) has shifted. More and more the photograph has come to be a component: incorporated into artworks as but one of many diverse elements in mixed-media, across-media presentations.

Marcel Duchamp essentially disrupted the Modernist art tradition in 1913 when he produced his first "ready-mades"—a urinal, a bottle rack, a bicycle wheel mounted on a stool—in an attempt to dislodge art's emphasis from the precious art object. This pure and simple isolation of the object out of context was also evident in the *objets trouvés* and other ambiguous artworks of the Surrealists. Some fifty years after Duchamp's flippant but nonetheless profound transformations, Andy Warhol, Robert Rauschenberg, and Ed Ruscha—seeking to depart from the highfalutin approach to art-making of the Abstract Expressionists—brought to their art with the "ready-

Timeline

1955
Warsaw Pact formed
Rosa Parks arrested for refusing to give up her seat on a bus, Montgomery, AL
James Agee, James Dean, Albert Einstein, and Charlie Parker die
The Family of Man, MoMA, NYC
Inexpensive transistor radios introduced
Disneyland opens, Anaheim, CA
The Mickey Mouse Club, Captain

Kangaroo, and *The $64,000 Question* premiere on TV
Village Voice begins publication
Rock Around the Clock, by Bill Haley and His Comets

1956
Egypt seizes the Suez Canal
Eisenhower reelected President
First nuclear-power generating plant, Great Britain
Bertolt Brecht, Tommy Dorsey, and Jackson Pollock die
This is Tomorrow, Whitechapel Art Gallery, London

Construction on Guggenheim Museum, by Frank Lloyd Wright, begins, NYC
Howl, by Allen Ginsberg
Heartbreak Hotel, Elvis Presley's first hit

1957
USSR launches *Sputnik* and the "space race" begins
Black students prevented from entering Central High in Little Rock, AR
Ford releases the Edsel
Bouffant hairdos become popular

Leave It to Beaver and *Wagon Train* premiere on TV
On the Road, by Jack Kerouac
Wake Up, Little Susie, by The Everly Brothers

1958
Nikita Khrushchev becomes Premier of the USSR
NASA established
First transatlantic jet service
Commercial copier introduced by Xerox
Paul Outerbridge and Edward Weston die

Allan Kaprow, environment, Hansa Gallery, NYC
Les Américains, by Robert Frank, published in France
Stereo LPs and hula hoops introduced
First Pizza Hut opens, Kansas City
At the Hop, by Danny and the Juniors

1959
Fidel Castro takes power in Cuba
Premier Nikita Khrushchev visits US
Alaska and Hawaii become states

made" mass-media photograph or the look of the "easily made" snapshot, the values of mass production, the banality of everyday imagery, and the appearance of an unauthored view. Their doing so unquestionably prompted a corresponding rethinking of photography's artistic role. New uses of the photograph by these artists—repeating media images silkscreened in a grid on a large canvas; paintings and collages with photographs and a variety of other materials; the "not arty"[5] photographs of apparently insignificant subjects presented in small books—were stunning departures from most conventional and traditional artworks of the day, most notably, "fine-art" photography. This was clearly a time of radical and dramatic changes in the form of the art object.

> Unmistakably, reproduction as offered by picture magazines and newsreels differs from the image seen by the unarmed eye. Uniqueness and permanence are as closely linked in the latter as are transitoriness and reproducibility in the former.
>
> —Walter Benjamin (1936)[6]

In his essay, Benjamin also acknowledged that with the means of mechanical reproduction and the ability for tremendous image multiplication from a single original, the "aura" of "authenticity" in relation to the viewers actual first-hand response and sentiment to the unique artwork would be lost. An important shift in the early 1960s was this departure from "unique" works of art to other, unconventional forms of expression and presentation. These new forms were no longer simply framed objects on the wall but included Happenings, Earthworks, Book Art, Fluxus, Performance Art, and Conceptual Art—artworks that not only abandoned the easel, but in many cases moved out of the gallery space entirely, a step that prompted an increased and broader creative use of the camera.

While numerous artists since the 1960s have utilized the strategy of incorporating many photographs into one artwork, the work included in *Special Collections* has been selected for the specific intentions with which the artists have assembled their photographs. These works are distinct from photographic representations that are pieced together to make a complete scene or combined to form a mosaic of many smaller photographs, as with many of David Hockney's photo-works from the late 1970s and early 1980s. Rather, these works—whose components are classified according to types, repeated because of similarities, and reproduced as a part of a system or the documentation of an activity—shun the notion of pictorial re-representation.

The significance of the individual photograph in the artworks in *Special Collections* is diminished, if not virtually inconsequential; the artistic process of image selection and subsequent presentation is first and foremost. In these artworks the notion of the masterpiece—in which the evidence of the artistic process is compressed into one singular, irreplaceable artwork—is attenuated with each photograph, whether it is part of an artwork comprised of only a few elements or of many thousands, all of which have equal value or importance to every other image in the collective artwork.

These collections of numerous photographs into specific arrangements, as in Neil Winokur's *Cindy Sherman: Totem* (1986); or into classifications according to similar subjects or characteristics, as in Richard Prince's *Palms and Decals* (1990), Judy Fiskin's *Geometric Facades* (1983), and Mitchell Syrop's *Constellations* (1992), are self-contained works that are in a sense taxonomic displays, much like scientifically organized collections of specimens. They are special collections of images, with the specific preconceptions of the artist creating multi-image, encyclopedic works that are reminiscent of the pages of the high-school yearbook, the mug-shot album, or the variety of types and sizes found in the industrial machine catalogue. And like these regimented displays, neatly and routinely organized row after row in a grid, numerous artworks in this exhibition also utilize the uniformity of the grid format.

First photographs of earth taken from space

Barbie doll and Velcro introduced

Naked Lunch, by William S. Burroughs

Breathless, directed by Jean-Luc Godard

Mack the Knife, by Bobby Darin

1960

John F. Kennedy elected President

OPEC founded

New Forms–New Media, Version II, Martha Jackson Gallery, NYC

Laser discovered, resulting in first hologram

Psycho, directed by Alfred Hitchcock

The Twist, by Chubby Checker

1961

Berlin Wall erected

Bay of Pigs invasion

Yuri Gagarin, Soviet cosmonaut, becomes first man in outer space

JFK creates Peace Corps

The Art of Assemblage, MoMA, NYC

NY Yankee Roger Maris breaks Babe Ruth's home-run record for a single season

To Kill a Mockingbird, by Harper Lee

1962

Cuban Missile Crisis

John Glenn becomes first American to orbit earth

Pentagon announces that US pilots are flying combat missions in Vietnam

Marilyn Monroe dies

Andy Warhol, Campbell's Soup paintings, Ferus Gallery, Los Angeles

John Steinbeck awarded Nobel Prize

One Flew Over the Cuckoo's Nest, by Ken Kesey

First James Bond movie, *Doctor No*, directed by Terence Young

1963

JFK assassinated; Lyndon B. Johnson becomes President

Martin Luther King delivers "I have a dream" speech

Georges Braque, Jean Cocteau, and Robert Frost die

Edward Ruscha, Ferus Gallery, Los Angeles

By or of Marcel Duchamp or Rrose Sélavy, Pasadena Art Museum, CA

Fluxus Festival in Düsseldorf, Germany

Touch-Tone telephone introduced

Instamatic camera and cartridge film introduced by Kodak

Instant color film introduced by Polaroid

Seemingly scientific purposefulness is also evident in the captions or titles of many of these works. In most instances the title is an integral if not essential component of the appreciation and understanding of what is presented. The commonplace and purely descriptive titles of such pieces as Ed Ruscha's *Every Building on the Sunset Strip* (1966), Christian Boltanski's *The 62 members of the Mickey Mouse Club in 1955* (1972), Garry Fabian Miller's *Honesty. The fertile months, the greening, the growing, the dying, the seeded hope* (1985), and Robbert Flick's *One Thousand Signs— along Lincoln Boulevard looking East. Culver to Wilshire to Culver, (7:30 a.m. to 5:15 p.m.)* (1990), provide detailed descriptions of the artist's intentions, to accompany the viewer's initial observations of the work. This information also contributes to the pedantic and/or comic intrigue of many works in *Special Collections*, including John Baldessari's *Horizontal Men (with One Luxuriating)* (1984), Robert Watts's *Chest of Moles, (Portrait of Pamela)* (1965–85), Susan Eder's *Fish Value Scale (Price Pyramid)* (1991), and Dennis Adams's *Patricia Hearst—from A to Z* (1979–89).

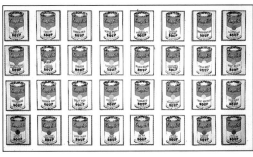

ANDY WARHOL
32 Soup Cans, 1961-62

Courtesy Blum Helman Gallery, New York City

Beyond sharing a similar strategy of presentation or execution of their artworks, the artists in *Special Collections* have been instrumental in the various artistic movements and emerging artistic issues of the past three decades. The cataloguing, classifying, and ordering of photographic images can be seen in many of the works from Pop to Postmodernism. The diversity of materials and approaches available to artists throughout the 1960s—video, installations, performance, book arts—spawned other alternative approaches to art-making in the 1970s that extended into the 1980s and 1990s. New presentations and technologies, often hybrids of techniques, all utilized or incorporated photographs. The photograph quickly became an integral and,

at times, an essential aspect of the new visual forms that have transformed the art world from Pop to now.

The things I want to show are mechanical. Machines have less problems. I'd like to be a machine, wouldn't you?

—Andy Warhol (1963)[7]

The most prevalent photographic images in the late 1950s and early 1960s could be found in the streets: in magazines and newspapers, on billboards and advertisements. Their subjects were, as Warhol put it, "images that anybody walking down Broadway could recognize in a split second— comics, picnic tables, men's trousers, celebrities, shower curtains, refrigerators, Coke bottles"[8] —all the great modern things that the Abstract Expressionist tried to forget. These types of lowbrow, mass-produced, mass-media images ultimately became the subjects of many of the startling new artworks in the 1960s, as the traditional forms of art—namely painting and sculpture—were reconsidered. The break from the conventional artistic and photographic forms echoed earlier 20th-century movements: the Surrealist and Dadaist works of the 1920s and 1930s by John Heartfield, Man Ray, László Moholy-Nagy, and El Lissitzky, and the "readymades" of Duchamp, which had instantly transferred art's infatuation from the precious art object and the significance of artistic production to a new emphasis on the artist's idea.

Duchamp was unquestionably the first artist to advocate, in an unaestheticized way, the use of existing objects in the name of art. This strategy of the appropriation of ordinary images or objects into an artwork—comic strips, cigarette ads, the American flag, beer cans, TV images, and soup

cans—became an essential tactic of Pop art. This approach —with its appropriation of everyday artifacts and everyday life—could in no way be confused with the traditional fine-art aesthetic. Typically, these new artworks took on popular culture, notions of mass production, and America's consumer society as their subtexts. Such works as Warhol's 1960 Campbell's Soup Can series departed radically from the high-minded, majestic paintings of the Abstract Expressionists of the 1950s, namely Jackson Pollock, Barnett Newman, Mark Rothko, Clyfford Still, and Willem de Kooning, making Warhol himself or his artistic analogy—the image of the soup can—the symbol of what Pop art was all about.

Shortly after the soup can paintings, Warhol took Pop one step further with the utilization of photographic silk-screening, a process by which he could make his appropriations more quickly and mass produce them. Warhol's 1962 photo-silkscreen *Baseball*, a photograph of Roger Maris hitting his record-breaking sixty-first home run, was appropriated from a newspaper photograph of this event. Warhol's interpretation was a mechanically reproduced painting in a giant grid that repeated the photograph from the newspaper front page—gritty and crudely defined—and propelled it to the forefront of artistic practice and discourse.

While Warhol gamely acknowledged the loss of originality in his mass-produced "Factory" techniques with the repetition of the borrowed mass-media image, what was equally significant to his use of the "grided" photograph was the dramatic shift in form of the photographic image—enlarged, repeated on canvas, and presented as a painting—that he engineered. This shift in form influenced the subsequent use of the photograph by artists and coincided with a new generation of photographers and image-makers departing from the look of the traditional art photograph.

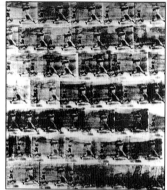

ANDY WARHOL
Baseball, 1962

The Nelson-Atkins Museum of Art, Kansas City, Missouri
(Gift of the Guild of the Friends of Art and a group of friends of the gallery)

Concurrent with Pop and running a parallel path was Fluxus, an art movement that even more than Pop rejected the notion of the rarefied art object and joyously renounced "high art." Also an outgrowth of the ideas of Marcel Duchamp as well as John Cage, Fluxus was not a mainstream, commercially viable art movement as Pop was. Robert Watts, a seminal figure in the Fluxus movement, incorporated the photograph into many of his works, including *FLUXPOST 17-17* (1964), a grid of postage-stamp portraits. Like Warhol's work at this time Watts's work also included the "borrowed" photographic image as a component in his work. Another work by Watts, *Chest of Moles, (Portrait of Pamela)* (1965–85), is a small, glass-fronted chest containing numerous small photographs embedded in plastic of the moles on a woman's skin; a taxonomic collection of specimens that have been documented, preserved, and presented with academic attentiveness, artistic inventiveness, and a hint of droll humor. Truly a departure from the conventional art of the preceding decade, Watts's artwork, like the Fluxus movement itself, "was serious about not being serious."[9]

Instead of scenes that seem like paintings, Siskind's pictures ARE paintings as they appear on the printed page—which is where most people today see paintings that they see. They are reproductions that have no originals.

—Harold Rosenberg (1959)[10]

Harold Rosenberg's observation in 1959 on the consequences of mechanical reproduction almost 30 years after Benjamin himself questioned the uniqueness of the photographic image was also significant. "Art photography," no matter how innovative the photographer at this time, still had painting as its measure, namely, Abstract Expressionist painting. Within a few years, as exhibitions of Pop art burst

onto the American cultural scene, photography, typically relegated to a marginal standing in relation to the more "serious" arts, would increasingly be utilized by artists in paintings and as a source for paintings and, as always, viewed in relationship to paintings. Not surprisingly, even with the photograph's growing acceptance and usage it was still "painting" that was seen as the pinnacle of artistic expression. Removed from its usual context (small and in a frame, magazine, or book) and placed in a revised context (enlarged, arranged in a grid, included in a collage with paint), the photograph took on a different stature and a new meaning.

The photographs that Warhol, Rauschenberg, and Ruscha used in their works were not at all like the photographic icons of the 1950s. Indeed, Warhol's and Rauschenberg's appropriated photographs were not theirs at all, and Ruscha's were so banal, so unartistic they could have been made by almost anyone. With these new uses of the photograph the author was of little consequence. But with the departure from the single, small-scale image, the photograph as utilized by Warhol and Rauschenberg now had the impact of a painting; their *photographs* were unquestionably *paintings*. Even Ruscha's images could be seen as such, as John Coplans, then curator and critic, observed in 1963: "Ruscha is the first artist in the [Pop] movement to have published…a book entitled 'Twenty-six Gasoline Stations.' A series of photographic images, it should be regarded as a small painting."[11]

The works that Ruscha was producing, while not on the grand scale of those of Warhol or Rauschenberg, nevertheless announced new forms and totally distinct uses of the photographic medium. The appearance of the seemingly unauthored view as seen in Ruscha's books *Twenty-Six Gasoline Stations* (1962), *Some Los Angeles Apartments* (1965), *Every Building*

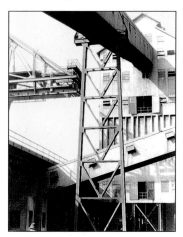

CHARLES SHEELER
Pulverizer Building – Ford Plant, 1927
The Lane Collection
Photo, Courtesy, Museum of Fine Arts, Boston

on the Sunset Strip (1966), *Nine Swimming Pools and a Broken Glass* (1968), and *Various Small Fires and Milk* (1964), evolved alongside Pop art (and from similar sources), but Ruscha's use of photography and the basic appearance of his images introduced a direct, minimal look to photography's lexicon. In retrospect Ruscha's intentionally unartistic photographs were in a sense precursors of the non-representational Minimalist aesthetic as well as the systemic, often witty works of the Conceptualists. With Ruscha's books, according to noted critic Benjamin Buchloch, "the mode of the presentation itself became transformed: instead of lifting photographic (or print-derived) imagery from mass-cultural sources and transforming these images into paintings…Ruscha would now deploy photography directly, in an appropriate printing medium."[12] As Buchloch also observed, Ruscha's photography "explicitly situated itself as much outside of all the conventions of art photography as outside of those of the venerable tradition of documentary photography."[13]

In the late 1950s, a few years before Ed Ruscha produced his photographic books and Warhol painted his soup cans, Bernd and Hilla Becher began to document various industrial architectural subjects—blast furnaces, water towers, lime kilns, cooling towers, half-timbered houses—producing objective records (the Bechers call them "typologies") of fast-disappearing industrial architecture. These photographs acknowledged the notion of the traditional photographic document but, like the works of Ruscha, broke from the conventional presentation. The rigid arrangements of six or nine photographs in a grid—dead-on views with a minimal aesthetic—were departures from the popular, romanticized Modernist views of early 20th-century industrialization that transformed banal industrial sites into gleaming futuristic visions—typified by Charles Sheeler's photographs of the Ford Motor plant in Dearborn, Michigan, in 1927. The grid formation

allows the meticulous photographs of these sometimes unusual, at other times beautiful structures to be compared, analyzed, and scrutinized.

The use of the grid by Bernd and Hilla Becher, Andy Warhol, and many other artists at the time was not in itself ground-breaking. In fact Modernist art, with its emphasis on the future, scientific invention, technology, and originality, adopted the grid, which is seen in the works of numerous artists prior to Warhol, namely: Piet Mondrian, Josef Albers, Ad Reinhardt, Jasper Johns, and Agnes Martin. Also adopted by the influential Conceptualist and Minimalist Sol LeWitt, the grid promised the hard-edged look of industrially manufactured materials; it removed the appearance of, or actually removed, the artist's hand from the artwork; and it provided a means for achieving the non-representational image. LeWitt's artworks, like the Minimalist work of Carl Andre and Kenneth Nolan, strived to eliminate any relationship to past artistic forms. With the use of the photograph and its rectangular regimented format and mechanical precision, LeWitt has extended his investigations to a presentation of like subjects that echoes the inherent repetition and reproducibility of the photographic process itself in what he calls "photo-grids." These give related but disparate subjects a false sense of order within an ordered display.

As seen in the works of many artists in *Special Collections*, the grid proclaims equality and consistency, it is symmetrical and modular, and it allows for orderly repetition. As writer and critic Rosalind Krauss has noted, "Structurally, logically, axiomatically, the grid can only be repeated. And, with an act of repetition or replication as the 'original' occasion of its usage within the experience of a given artist, the extended life of the grid in the unfolding progression of his work will be one of still more repetition, as the artist engages in repeated acts of self-imitation."[14] Employed in distinct and varied ways by many of the artists and photographers in *Special Collections*—Bernd and Hilla Becher, Christian Boltanski, Robert Heinecken, Rick Hock, Sol LeWitt, Garry Fabian Miller,

Robbert Flick, Arnaud Maggs, Richard Prince, Mitchell Syrop, and Robert Watts—the grid fulfills these artists' shared desire for a formalist, quasi-scientific, non-hierarchical, and ultimately Modernist strategy for a form of presentation that accommodates the cataloguing of photographic information and/or images that by definition are geometric, modular, mathematical, and orderly, and yet allows for unlimited possibilities.

Everywhere progress is being made in the acceptance of photography as a valid, vital and needful art form.
—Beaumont Newhall (1964)[15]

In 1967, just a few years after the Pop explosion, the landmark photography exhibition "The Persistence of Vision" at the George Eastman House in Rochester, New York, made it clear that art photography (as distinct from the use of photographs by artists) had undergone profound change. In the exhibition catalogue, curator Nathan Lyons contended: "Today the photograph is being considered as a relative artifact of metaphoric concern, much in the same sense as an automobile, comic strip, or soup can. If we consider man's visualizing activities in relation to the photographic picture, then we may readily understand how the nature of sequential concerns, or the multiple exposure, might be considered more naturalistic perceptually than our traditionally held concept of the *straight photograph*."[16]

Lyons noted that the work of photographers such as Donald Blumberg, Charles Gill, Robert Heinecken, Ray Metzker, Jerry Uelsman, and John Wood was atypical of photography prior to that time, and that the photograph was no longer going to be simply a "straight" singular image. Metzker, with his repetitive strips of images as seen in *Telephone Booth* (1966) (see figure on page 21), and Heinecken, with his use of photograms and images from mass media, began expanding the potential of the photographic medium. By utilizing multiple exposure, alternative printing techniques, new imaging technologies, and various formats, this new generation of photog-

raphers departed sharply from the status quo. With their many revised and refined applications of the photograph, they succeeded in debunking the traditional canons of art photography and creating a different kind of photography, a different photographic order.

Looking at this shift in photography's aesthetic, art critic Andy Grundberg observed in 1987 that "a pivotal change in attitude was the focus on *photography* rather than on the *photograph*, for the photograph was fettered by tradition, while photography as a medium covered any kind of photographic imagery, and could accommodate great latitude."[17] This latitude, coupled with the desire of artists in the 1960s and early 1970s to "de-materialize"[18] the art object, made photography the perfect vehicle for aesthetic revolution. The drastic departures instigated by Warhol and Rauschenberg and a host of Pop artists and the concurrent revisions of photographic presentations by photographers themselves took advantage of this shift.

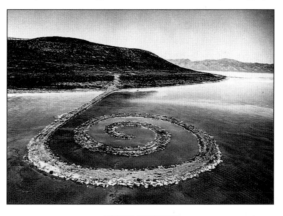

ROBERT SMITHSON
Spiral Jetty, 1970

Estate of Robert Smithson, Courtesy John Weber Gallery, New York City

With a camera in their hands and a newfound awareness of its potential, artists involved in Conceptual Art, Happenings, and Earthworks not only inadvertently subverted many of the long-standing conventions of "art photography," they did so while simultaneously embracing photography's veracity. With an ever-increasing awareness of the photograph's potential as an adjunct to the artistic process, the notion of the artist and the camera became commonplace. For ephemeral forms of art such as Earthworks and Happenings that could be experienced directly by just a handful of participants, and often for only a short period of time, photography, in many instances, was the only form through which that artwork could be brought to a

larger audience. For large-scale Earthworks, artworks utilizing remote locations and the land itself as the creative medium, as in the case of Robert Smithson's *Spiral Jetty* (1969), the photographs are now the only evidence of this seminal work since its erasure by the rising water of the Great Salt Lake.

Allan Kaprow's Happenings, begun in the late 1950s, also relied on the photograph as evidence of these enigmatic, illogical, and seemingly unpredictable events. Happenings were an art form that denied any boundaries in the conventional sense of art; they were without a doubt mixed-media, mixtures of this or that. Based on instructions given by the artist as to what to do when, where, and how, Happenings also had a good measure of chance and improvisation. The camera became for most people the only connection to the actual event or artwork, a mechanical liaison for the comprehension and appreciation of what was unquestionably not a static work of art. In describing *Days Off: A Calendar of Happenings* (1970), Kaprow states: "This is a calendar of past events. The days on it are the days of the Happenings. They were days off. People played."[19] Like the photo album, Kaprow's *Days Off* is a simple and direct presentation of his collection of photographic documents. The photographs (calendar)—arranged chronologically and according to the specific Happenings—give the randomness of these playful days and disparate multi-faceted events and places a structure, allowing for a post-facto look at an elusive art form and a documentation of these fleeting moments.

All art after Duchamp is conceptual in nature because art only exists conceptually.

—Joseph Kosuth (1969)[20]

The notion of temporal art that typified Happenings and the so-called "dematerialization" of the art object reached its logical conclusion in Conceptual Art. Shortly after the Pop movement, photography—and a variety of photo-mechanical processes—was used increasingly by such Conceptual artists as Joseph Kosuth, Dennis Oppenheim, Eleanor Antin, Dan Graham, Hans Haacke, Bruce Nauman, Alice Aycock, Jan Dibbets, and Douglas Huebler. "In conceptual art," as Sol LeWitt defined it, "the idea or concept is the most important aspect of the work. When an artist uses a conceptual form of art, it means that all of the planning and decisions are made beforehand and the execution is a perfunctory affair."[21]

Within Conceptual Art the photograph serves as a document, a surrogate for the actual work. With the *idea* central to Conceptualism, the actual art object was no longer the primary consideration; indeed, for many Conceptual works the actual "piece" was secondary and at times virtually invisible.[22] For Douglas Huebler and many other Conceptual artists of the late 1960s to the early 1970s, the photograph was the perfect collaborator: art that was "anti-art" could be realized through a means that still had a somewhat tentative association with "art."

The photograph has been a significant part of the ongoing Conceptual works that Huebler began in the late 1960s. In fact, Huebler was one of the first artists of the 1960s to acknowledge the objectivity of the camera and its potential in the production of conceptually based artworks. The text for one of these works reads: "Throughout the remainder of the artist's life he will photographically document, to the extent of his capacity, the existence of everyone alive in order to produce the most authentic and inclusive representation of the human species that may be assembled in that manner."[23] Although Huebler will never achieve his stated aim, the idea, not the execution, is of primary significance. As Huebler has noted, his photographs have no aesthetic value and are not considered "good" photographs in the conventional sense. The camera serves simply as an objective tool to implement the artist's ideas and record the execution of these ideas. For Huebler the idea of the overall classification and presentation of "everyone alive" is without a doubt the ultimate collection of photographic documentation—an ironic yet calculated twist to the futility of scientific rigor.

John Baldessari also utilized the objective potential of the camera with artworks that are reminiscent of Ruscha's books and the structured Conceptual works of Huebler. Working with preconceived titles and strategies, Baldessari has continually been intrigued with notions of order and chaos. "For us to see things, the mind has to order information. Otherwise things become just a bunch of retinal stimulation."[24] In such works as *The Back of All Trucks Passed While Driving from Los Angeles to Santa Barbara, California. Sunday 20 January 1963* (1963), *Alignment Series: Things in My Studio (By Height)* (1975), and *Color Car Series: All Cars Parked on the West Side of the Street, Between Bay and Bicknell Streets, Santa Monica at 1:15 P.M., September 1, 1976* (1976), Baldessari goes beyond simply cataloguing and classifying aspects of his day-to-day comings and goings. By combining disparate photographs and juxtaposing text with images, Baldessari reveals civilization's "thin veneer over a chaos that may erupt at any moment."[25] With his more recent artworks of the 1980s, such as the two works in *Special Collections, Four Types of Chaos/Four Types of Order* (1984) and *Horizontal Men (with One Luxuriating)* (1984), Baldessari departed from taking his own photographs and adopted a strategy that became synonymous with Postmodernism—borrowing or appropriating photographs to accommodate his continued interest in bringing order to the world.

The seemingly insatiable appetite for photography in the 1970s expresses more than the pleasures of discovering and exploring a relatively neglected art form; it derives much of its fervor from the desire to reaffirm the dismissal of abstract art, which was one of the messages of the pop taste of the 1960s.

—Susan Sontag (1977)[26]

Lech Walesa and workers form Solidarity union, Poland

Dozens of nations boycott Moscow Summer Olympics

Gold rush in Amazon jungle, Brazil

Jean-Paul Sartre dies and John Lennon shot dead

First consumer Camcorder introduced by Sony

Graffiti becomes recognized as an "art" form

Cable News Network (CNN) debuts on cable TV

The Executioner's Song, by Norman Mailer

The Elephant Man, directed by David Lynch

1981
Researchers identify AIDS

Iranian hostage crisis ends

Egypt's president, Anwar Sadat, assassinated

Reagan shot and wounded in assassination attempt

Sandra Day O'Connor becomes first female Supreme Court justice

First reusable spacecraft, space

shuttle *Columbia*

Personal computer marketed by IBM

MTV debuts on cable TV

A Confederacy of Dunces, by John Kennedy Toole

Raiders of the Lost Ark, directed by Steven Spielberg

1982
Falkland War

Israel invades Lebanon

Break up of AT&T

Tylenol scare

First artificial heart transplant, *Jarvik 7*, in Utah

Image Scavengers: Photography, ICA, University of Pennsylvania, Philadelphia

Disk camera and fifteen picture film disk introduced by Kodak

USA Today newspaper launched

Rabbit is Rich, by John Updike

E.T., The Extraterrestrial, directed by Steven Spielberg

Ebony and Ivory, by Paul McCartney and Stevie Wonder

1983
US invades Grenada

Philippine opposition leader Benigno Aquino assassinated

Challenger astronaut Sally K. Ride becomes America's first women in space

Bill Brandt and Lisette Model die

Martin Luther King Day becomes a national holiday

The Color Purple, by Alice Walker

The Big Chill, directed by Lawrence Kasdan

Thriller, by Michael Jackson breaks

Unlike the 1960s, with its distinct art movements—Pop, Minimal, Conceptual, Fluxus, Earthworks—the 1970s on the other hand was a time of pluralism; a time of no specific or dominant artistic trend. The 1970s also saw the Watergate break-in, the resignation of a president, the end of U.S. involvement in the Vietnam War, CB radios, disco, and happy-face buttons, along with widespread emergence of such political movements as the Women's Movement, Gay Pride, and Black Power. Throughout the country in the 1960s and 1970s photography programs were instituted and expanded at colleges and universities; museums and alternative spaces devoted exclusively to photography were opening in large and small cities; books and magazines concerning photography were being published by the dozens.

As a result of this ongoing exploration of approaches to art-making and the departure from the limitations of working with specific mediums such as painting or sculpture, the photograph, as Susan Sontag has noted, and its wholesale adoption by artists in a variety of forms, characterized much of the disparate artistic activity of this decade. During this time artists like Dennis Adams, Christian Boltanski, Sarah Charlesworth, Louise Lawler, and Annette Messager increasingly began to use the photograph as a part of their multifaceted artistic explorations. Their artworks in the 1980s would later evolve and depart even further from the traditional notion of the masterpiece with installations—room-size orchestrations of photographs and other materials (Boltanski); with bus shelters as urban art (Adams); with text, sculptural elements, clothes, dolls, twine, etc. (Messager); or with the straightforward photographic documentations that commented on the role of art in culture and the commodification of the art object (Lawler). These were artworks that not only utilized multiple images but extended the use of the photograph into an expanded arena.

The appropriation of images, initiated by the Pop artists, began to resurface in much of the artwork of the 1970s and 1980s. Pop art's interest in vernacular imagery, Conceptual Art's inventory systems or games, and Minimalism's harsh industrial edge were evident in the new artworks and accompanying critical discourse of Postmodernism. The Postmodern generation of artists grew up in the 1950s and 1960s, and was the first generation to be inundated by the flood of images and information from both print and electronic media and exposed to the dramatic artistic transformations that began with Pop art. They witnessed the formation of the concept of collective memory, as the Hollywood movie still, the advertising image, the front-page photograph, and, of course, the unblinking emissions of television became engraved on the public consciousness. Simply put, the Postmodern artist believes that the world is overrun with images of all types—printed, photocopied, televised, recorded, filmed—to the point that the concept of originality is no longer possible. As Douglas Crimp, editor of *October* magazine described in 1980: "A group of young artists working with photography have addressed photography's claims to originality, showing those claims for the fictions they are, showing photography to be always *re*presentation, always-already-seen. Their images are purloined, confiscated, appropriated, stolen."[27]

Postmodernism's scavenging of images from other sources also has its roots in the ready-mades of Duchamp. The potential and predicament of mass image reproduction were the fulfillment of what Walter Benjamin prophesied fifty years earlier—the farewell to the authentic artwork. His essay was significant to much of the critical discourse of the Postmodern period, and photography, the most accessible form of mechanical reproduction, with its capacity to be effortlessly and infinitely reproduced, was central to much of the Postmodern dilemma.

The properties of photographic imagery which have made it a privileged medium in postmodern art are precisely those which for generations art photographers have been concerned to disavow.

—Abigail Solomon-Godeau (1984)[28]

all sales records
1984
Indira Gandhi assassinated
Bernhard Goetz shoots four black youths on NYC subway
Leak at Union Carbide plant kills more than 2,000 in Bhopal, India
Ansel Adams, Brassaï, and Garry Winogrand die
Blam! The Explosion of Pop, Minimalism, and Performance, 1958–64, Whitney Museum of American Art, NYC

First electronic still camera introduced by Canon
McDonald's sells 50 billionth hamburger
The Unbearable Lightness of Being, by Milan Kundera
Like A Virgin, by Madonna
1985
Mikail Gorbachev becomes General Secretary of USSR
Scientists discover hole in ozone layer
1912 *Titanic* wreckage discovered

AT&T building completed, by Philip Johnson with John Bergee, NYC
Live Aid reaches worldwide audience of 1.5 billion
Prizzi's Honor, directed by John Huston
We Are the World, by USA for Africa
1986
Chernobyl nuclear disaster, Ukraine
US launches air strike against Libya
Challenger explodes, NASA sus-

pends shuttle program
Ferdinand Marcos flees Philippines and seeks asylum in Hawaii
The Real Big Picture, Queens Museum, Flushing, NY
Lonesome Dove, by Larry McMurtry
Blue Velvet, directed by David Lynch
1987
Gorbachev-Reagan summit, Washington, DC

Stock market plunges 508 points
Intifadah begins in Israel; riots continue into 1992
NYC's garbage barge rejected by several states and three foreign countries
Andy Warhol dies
Photography and Art: Interactions Since 1946, Los Angeles County Museum of Art
A Summons to Memphis, by Peter Taylor
Fatal Attraction, directed by Adrian Lyne

A more recent version of the Duchampian ready-made is also seen with the image appropriation in many artworks in *Special Collections*, including Rick Hock's use of disparate magazine, book, or TV images, Richard Prince's magazine appropriations, Mitchell Syrop's re-photographed high-school yearbook portraits, Dennis Adams's found images of Patricia Hearst, Christian Boltanski's re-photographed portraits of the Mickey Mouse Club members, and Andy Warhol's usage of images from mass media. These artworks address socio-political issues from the time of innocence in the 1950s to the age of terrorism of the 1970s, and the overwhelming crush of information and instant this or that typified by our contemporary society.

Richard Prince's photo-based, media-derived appropriations were among the first Postmodern works of the 1970s. Nevertheless, one of the major tenets of Postmodernism—the adoption of popular culture and the unaltered use of the mass-media image—can be traced to Pop art, namely Andy Warhol and Robert Rauschenberg. Prince's "gangs"—photographic works made up of images drawn from magazines—combine everything from bikers and their girlfriends to bitches and bastards to criminals and celebrities to palm trees and decals.

Arents Tobacco Collection and Arents Collection of Books in Parts, New York Public Library

Prince's large-scale works differ from Warhol's grids in that they do not only repeat the same image. Nevertheless, Prince's "gangs," which he began in the early 1980s, are reminiscent of Warhol's paintings not only in format but also in his choice of images, although Prince's selection in some cases is associated with a less desirable, darker side of American culture. While Warhol's artworks of car crashes, suicide victims, and the electric chair were intended to shock and to be "art" that didn't look like "art," Prince's inclusion of images drawn from motorcycle, hot-rod, or surfing magazines

addresses the pervasiveness of media imagery and presents what amounts to a "cataloguing of cultural image patterns."[29]

spe´cial collec´tion, *a collection of materials segregated from a general library collection according to form, subject, age, condition, rarity, source, or value.*[30]

The most formidable and extensive cataloguing of culture is seen within galleries and store rooms of most museums. By definition, a museum is a site or space that has been designated for the collection, conservation, study and the conscientious presentation of objects in historical context. Within the library or museum the designated "special collections" are even more specific than the overall inventory or collection. The desire of society to preserve its cultural heritage, interestingly, is closely linked to the use of the camera in our culture at large.

The photograph reassures us that memories will not be forgotten, that fleeting events will be captured, that faces will appear forever youthful, and that the pure and simple collection of information and raw data will happen almost effortlessly. This almost religious collecting and preserving of masses of images is clearly evident not only in the image appropriations where the artist hunts through magazines or file drawers for a specific image, but also in the quest on the streets or across the countryside for this subject or that object.

Today, the debate over photography's legitimacy as an art form—which began shortly after the invention of photography and well before Walter Benjamin's assertion in his essay *The Work of Art in the Age of Mechanical Reproduction*—is mean-

ingless. With the notion of the undermining of originality and authenticity as initiated by Duchamp, articulated by Benjamin, and capitalized on and catapulted to international visibility via the canvas by Warhol, the photograph has truly become important, if not central to contemporary art.

The rapid emergence of alternative modes of artistic expression from traditional forms such as painting and sculpture, and the simultaneous departure from the easel and at times the studio by many artists in the past three decades, have meant increased usage of the photograph by artists and a phenomenal acceptance of photography as a fine art throughout our culture. With the appearance of new artistic forms over the last thirty years, ranging from the wholesale scavenging of photographic images from the vernacular and mass media, to the actual compulsive accumulation of numerous (and at times a seemingly endless number of) photographs that are then ordered in works of art, the notion of the single "authentic" artwork has been radically transformed.

Anthropologists have explained that the urge to give order is inherent in human nature. It could be surmised that in a culture that is overrun with images to a point that their informational and utilitarian value becomes not only a conditioned blur but something more akin to a constant visual hum, an artist's impulse to order this visual overload is not only logical, it is inevitable. The artists in *Special Collections* have found the photographic medium to be the precise tool for their own specific ordering strategies. Remembering that the camera is a machine and that photography is essentially a science, it becomes clear that the photographic process is perfectly suited for this artistic collecting, classifying, archiving, and ordering. Indeed, no other form could have triggered the change in the art world in the ways that the photograph has in the last thirty years.

— Charles Stainback

Notes

1. Lucretius, *On the Order of Things*, trans. William Ellery Leonard (New York: E.P. Dutton and Company, Inc., 1950), p. 82.

2. Yogi Berra, in *Episode: Report on the Accident Inside My Skull*, by Eric Hodgins (New York: Simon and Schuster, 1963), p. 54.

3. Walter Benjamin, "The Work of Art in the Age of Mechanical Reproduction," in *Illuminations*, ed. Hannah Arendt, trans. Harry Zohn (New York: Schocken Books, 1969), p. 223.

4. Richard Prince's use of the term "gangs" to describe his photographic works in grids comes directly from the photographic or the printing trade jargon. The term "ganging-up" or "gang" printings is used when numerous photographs are printed in a "gang" on one large sheet. Typically, however, after the images are printed they are cut down to smaller sizes and not left on the single sheet.

5. John Coplans, "Concerning 'Various Small Fires'—Edward Ruscha Discusses His Perplexing Publications," *Artforum* 3, 5 (February 1965), p. 25.

6. Benjamin, "The Work of Art in the Age of Mechanical Reproduction," p. 223.

7. "Pop Art—Cult of the Commonplace," *Time*, May 3, 1963, p. 72.

8. Pat Hackett and Andy Warhol, *POPism: The Warhol '60s* (New York: Harcourt, Brace, Jovanovich, 1980), p. 31.

9. Owen Smith, "Art, Life and the Fluxus Attitude," in Susan Hapgood and Cornelia Lauf, eds., *FluxAttitudes* (Ghent, Belgium: Linschoot uitgervers, 1991), p. 58.

10. Harold Rosenberg, "Evidences," introduction to *Aaron Siskind, Photographs* (New York: Grove Press 1959), [Also published in *Art News*, September 1959, "The Camera and Action Painting."]

11. John Coplans, "American Painting and Pop Art," in *Pop Art USA* (Oakland, California: Oakland Museum, 1963), p. 14.

12. Benjamin H.D. Buchloch, "Conceptual Art 1962–1969: From the Aesthetic of Administration to the Critique of Institution," *October* (Winter 1990), p. 122. [An earlier version of this essay was published in *L'art conceptuel: une perspective* (Paris: Museé d'art moderne de la Ville de Paris, 1989).]

13. Ibid., p. 122.

14. Rosalind Krauss, "The Originality of the Avant-Garde: A Postmodernist Repetition," in Brian Wallis, ed., *Art After Modernism: Rethinking Representation* (New York: The New Museum of Contemporary Art, 1984), p. 21.

15. Beaumont Newhall, *The History of Photography from 1839 to Present Day* (New York: The Museum of Modern Art in collaboration with George Eastman House, Rochester, New York, dist. Doubleday & Co., Garden City, New Jersey, 1964), p. 201.

16. Nathan Lyons, *The Persistence of Vision* (New York: Horizon Press in collaboration with the George Eastman House, Rochester, New York, 1967), p. 5.

17. Andy Grundberg, "Breaking the Mold: Experiments in Technique and Process," in Andy Grundberg and Kathleen McCarthy Gauss, eds., *Photography and Art Interactions Since 1945* (New York: Museum of Modern Art, Fort Lauderdale: Los Angeles County Museum of Art, Abbeville Press, Publishers, 1987), p. 107.

18. "Dematerialism" is a term that first came into prominence in the mid-1960s to describe the shift away from the precious "art object" to forms that were much less regimented or limiting than painting and sculpture. Lucy Lippard chronicles this tenet in *Six Years: The dematerialization of the art object from 1966 to 1972* (New York: Praeger Publishers, 1973).

19. Lawrence Alloway, "Allan Kaprow, Two Views," in *Topics in American Art Since 1945* (New York: WW Norton & Company, Inc., 1975), p. 199.

20. Joseph Kosuth, "Art After Philosophy," *Studio International* 178, 915 (October 1969), p. 135.

21. Sol LeWitt, "Paragraphs on Conceptual Art," *Artforum* 5, 10 (Summer 1967), p. 80.

22. *Airshow*, 1967, by Terry Atkinson and Michael Baldwin. A conceptual work that declared one square mile of air to be art.

23. Douglas Huebler, text that accompanies an ongoing series of works. See *Variable Piece no.70 (In Process) Global 598*, 1975, p. 31.

24. John Baldessari, quoted in Coosjie van Bruggen, "Interlude: Between Questions and Answers," in *John Baldessari* (New York: Rizzoli International Publications, 1990), p. 38.

25. Coosjie van Bruggen, "The Art of Misleading Interpretation," in *John Baldessari* (New York: Rizzoli International Publications, 1990), p. 216.

26. Susan Sontag, "Photographic Evangels," in *On Photography* (New York: Farrar, Strauss and Giroux, 1977), p. 130.

27. Douglas Crimp, "Photographic Activity of Postmodernism," *October* 15 (Winter 1980), p. 98.

28. Abigail Solomon-Godeau, "Photography After Art Photography," in Brian Wallis, ed., *Art After Modernism: Rethinking Representation* (New York: The New Museum of Contemporary Art, 1984), p. 76.

29. Jeffrey Riam, "An Interview with Richard Prince," *Art in America* (March 1987), p. 87.

30. *Random House Dictionary of the English Language*, second edition/unabridged (New York: Random House, 1987), p. 1831.

Pretty Woman, directed by Garry Marshall

Please Hammer Don't Hurt 'Em, by MC Hammer

1991

Persian Gulf War

Gorbachev resigns as leader of Soviet Union

Soviet Union is dissolved with formation of Commonwealth of Independent States

Four white policemen are videotaped beating black motorist Rodney King, Los Angeles

Anita Hill/Clarence Thomas hearings

European Community nations sign unity treaty, Maastricht, Netherlands

Yugoslavia republics—Croatia and Slovenia—declare independence

Magic Johnson announces he is HIV positive

Frank Capra, Miles Davis, Edwin Land, Robert Motherwell, and Dr. Seuss die

JFK, directed by Oliver Stone

Smells Like Teen Spirit, by Nirvana

1992

Policemen acquitted for beating Rodney King; riots erupt in Los Angeles

Earth Summit held in Brazil

Civil War in El Salvador ends

R.H. Macy & Co. files for bankruptcy

Johnny Carson retires from *The Tonight Show*

The Player, directed by Robert Altman

Bill Clinton elected President

Timeline Bibliography:

Brownstone, David and Irene Franck. *20th Century Culture: A Dictionary of the Arts and Literature of Our Time*. New York: Prentice Hall, 1991.

Dickson, Paul. *Timelines: Day by Day and Trend by Trend from the Dawn of the Atomic Age to the Gulf War*. Addison-Wesley Publishing Company, Inc., 1991.

Hitchings, Thomas E., editor in chief. *Facts on File Yearbook*, 1989, 1990 1992. New York: Facts on File.

International Museum of Photography at George Eastman House, Rochester, New York, CDROM timeline

Livingstone, Marco. *Pop Art: An*

International Perspective. New York: Rizzoli International Publications, Inc., 1992

Stich, Sidra. *Made in USA: An Americanization in Modern Art, The 50s & 60s*. London: University of California Press, 1987.

Turner, Peter. Timeline, 1985 exhibition, *American Images: Photography 1945-1980*, Barbican Art Gallery, London, England.

Weaver, Mike. *The Art of Photography 1839-1989*. New Haven and London: Yale University Press, 1989. (The Royal Academy of Arts, London)

Wetterau, Bruce. *The New York Public Library Book of Chronologies*. New York: Prentice Hall Press, 1990.

I scrutinized Andy's photograph collection... The photos were an odd assortment of car crashes, people being tortured, candid and posed movie stars, and nature lovers. I realized that the photos were the actual subject matter Andy reproduced in his silk-screens. From these photos, Andy was taking what he wanted stylistically from the media and from commercial art, elaborating and commenting on a technique and vision that was to begin with second-hand. He was a Social Realist in reverse; he was satirizing the methods of commercial art as well as the American Scene. But instead of satirizing the products themselves, he had satirized the "artful" way they were presented.

– Gerald Malanga

Excerpt from "A Conversation with Andy Warhol," by Gerald Malanga, *The Print Collector's Newsletter* I, 6, January – February 1971, p. 125.

Andy Warhol
Crowd, 1963

Ray Metzker
Telephone Booth, 1966 (detail)

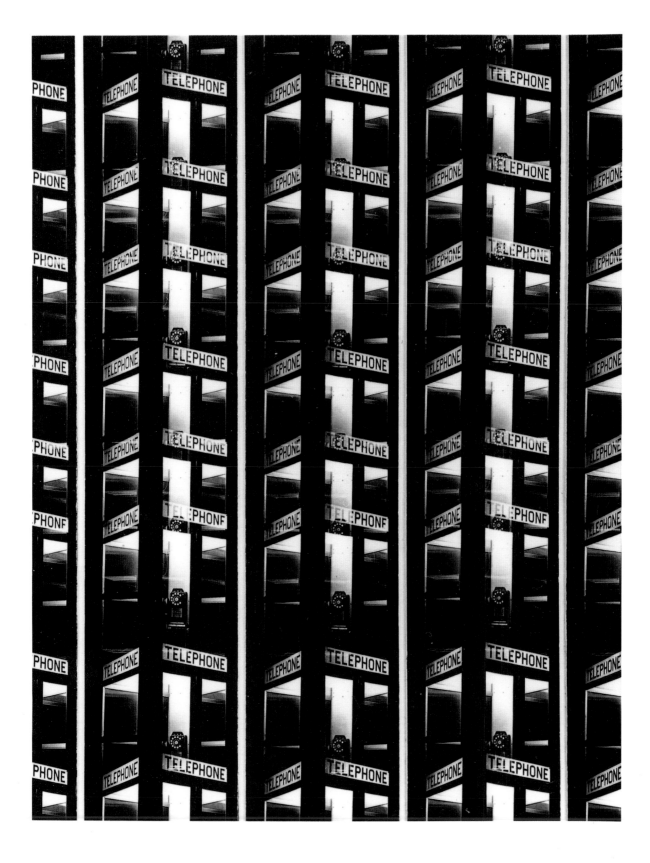

Above all, the photographs I use are not "arty" in any sense of the word. I think photography is dead as a fine art; its only place is in the commercial world, for technical or information purposes. I don't mean cinema photography, but still photography, that is, limited edition, individual, hand-processed photos. Mine are simply reproductions of photos. Thus, it is not a book to house a collection of art photographs – they are technical data like industrial photography. To me, they are nothing more than snapshots.

– Edward Ruscha

Excerpt from the interview, "Concerning 'Various Small Fires'– Edward Ruscha Discusses His Perplexing Publications," by John Coplans, *Artforum* III, 5, February 1965, p. 25.

Edward Ruscha
Every Building on the Sunset Strip, 1966

…Objects of every sort are materials for the new art: paint, chairs, food, electric and neon lights, smoke, water, old socks, a dog, movies, a thousand other things which will be discovered by the present generation of artists. Not only will these bold creators show us, as if for the first time, the world we have always had about us, but ignored, but they will disclose entirely unheard of happenings and events, found in garbage cans, police files, hotel lobbies, seen in store windows and on the streets, and sensed in dreams and horrible accidents. An odor of crushed strawberries, a letter from a friend or a billboard selling Draino; three taps on the front door, a scratch, a sigh or a voice lecturing endlessly, a blinding staccato flash, a bowler hat – all will become materials for this new concrete art.

The young artist of today need no longer say "I am a painter" or "a poet" or "a dancer." He is simply an "artist." All of life will be open to him. He will discover out of ordinary things the meaning of ordinariness. He will not try to make them extraordinary. Only their real meaning will be stated. But out of nothing he will devise the extraordinary and then maybe nothingness as well. People will be delighted or horrified, critics will be confused or amused, but these, I am sure, will be the alchemies.

– Allan Kaprow

Excerpt of "The Legacy of Jackson Pollock," by Allan Kaprow, *ARTnews* LVII, 6, October 1958, pp. 56-7.

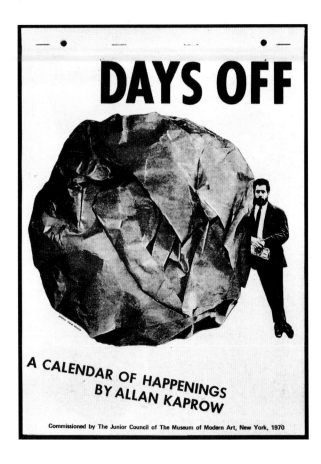

Allan Kaprow
Days Off: A Calendar of Happenings, 1970

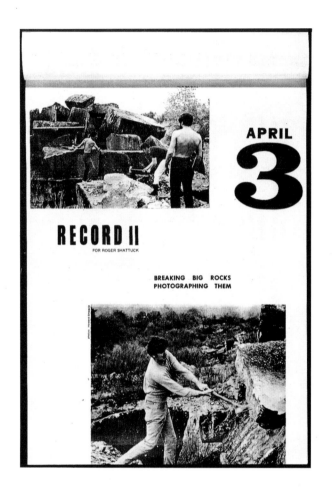

APRIL
3

RECORD II
FOR ROGER SHATTUCK

BREAKING BIG ROCKS
PHOTOGRAPHING THEM

APRIL
4

SCATTERING THE PHOTOS
WITH NO EXPLANATION

Bernd & Hilla Becher
Typology Watertowers, 1972

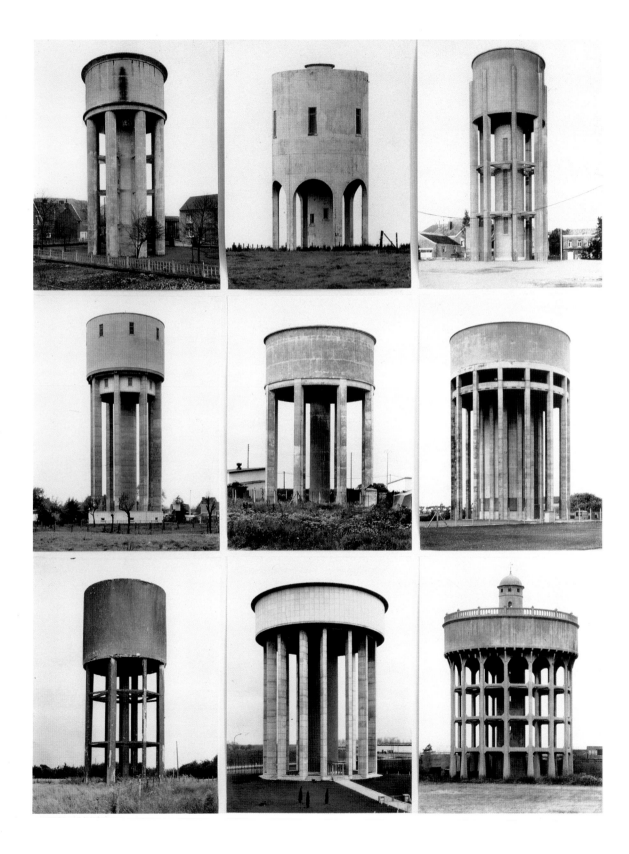

I was eleven years old in 1955 and I resembled these sixty-two children, whose photos were pictured in that year's Mickey Mouse Club magazine. They had each sent in the picture that, according to their opinion, represented them best: smiling and well-groomed or with their favorite toy or animal. They had the same desires and the same interests that I did. Today they must all be about my age, but I can't learn what has become of them. The picture that remains of them does not correspond anymore with reality, and all these children's faces have disappeared; on the second page of the Mickey Mouse Club magazine, other similar and interchangeable faces have replaced them.

Uncle Leon, the president of the club, a mythic figure, continues to write his letters to the "dear, little readers" and the children send their photos in again. Everything happens as if the recollections that I see did not lie in my memory, but in the present which surrounds me.

— Christian Boltanski

From the artist's statement in the exhibition, "Monumenta," Städtische Kunsthalle, Düsseldorf, 1973.

Christian Boltanski
The 62 members of the Mickey Mouse Club in 1955, 1972

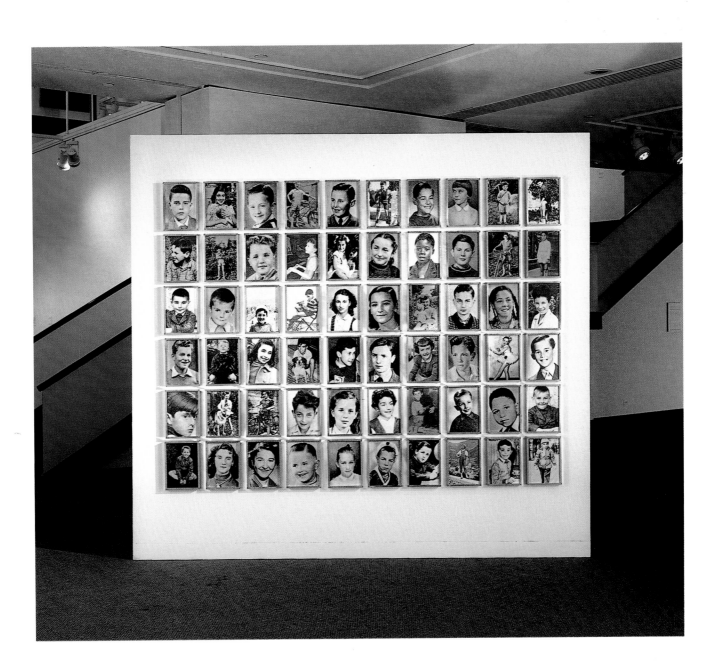

The world is full of objects,
more or less interesting; I
do not wish to add any more.

I prefer, simply, to state the
existence of things in terms
of time and/or place.

More specifically, the work
concerns itself with things
whose inter-relationship is
beyond direct perceptual
experience.

Because the work is beyond
direct perceptual experience,
awareness of the work depends
on a system of documentation.

This documentation takes
the form of photographs, maps,
drawings and descriptive
language.

– Douglas Huebler

From the catalog statement accompanying the exhibition, "January 5 – 31, 1971," Seth Siegelaub, New York City.

Douglas Huebler
Variable Piece no.70 (In Process) Global 598, 1975

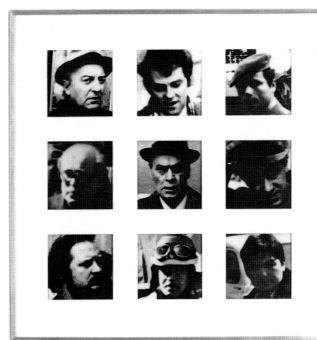

Sentences on Conceptual Art

1. Conceptual Artists are mystics rather than rationalists. They leap to conclusions that logic cannot reach.

2. Rational judgements repeat rational judgements.

3. Illogical judgements lead to new experience.

4. Formal Art is essentially rational.

5. Irrational thoughts should be followed absolutely and logically.

6. If the artist changes his mind midway through the execution of the piece he compromises the result and repeats past results.

7. The artist's will is secondary to the process he initiates from idea to completion. His wilfulness may only be ego.

8. When words such as painting and sculpture are used, they connote a whole tradition and imply a consequent acceptance of this tradition, thus placing limitations on the artist who would be reluctant to make art that goes beyond the limitations.

9. The concept and idea are different. The former implies a general direction while the latter are the components. Ideas implement the concept.

10. Ideas alone can be works of art; they are in a chain of development that may eventually find some form. All ideas need not be made physical.

– Sol LeWitt

Excerpt of "Sentences on Conceptual Art," by Sol LeWitt, *0-9* no. 5, January 1969, pp. 3–5.

Sol LeWitt
Photogrids, 1977 (detail)

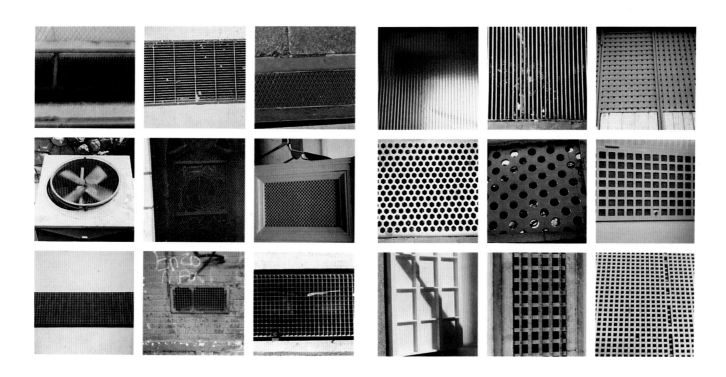

Dennis Adams
Patricia Hearst – A to Z, 1979-89

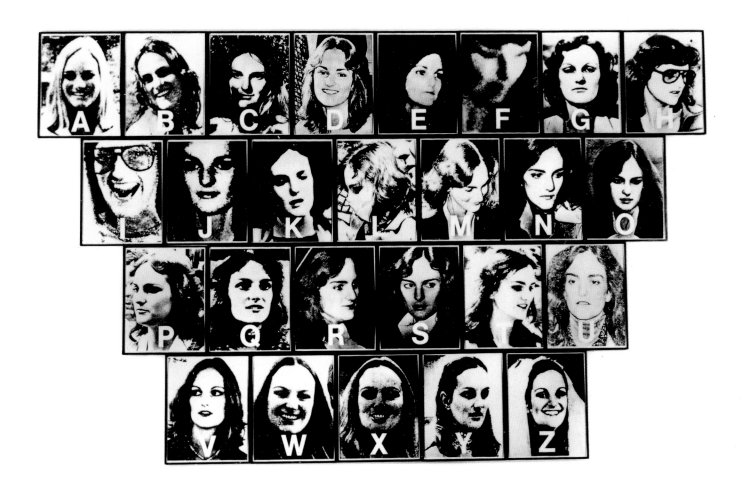

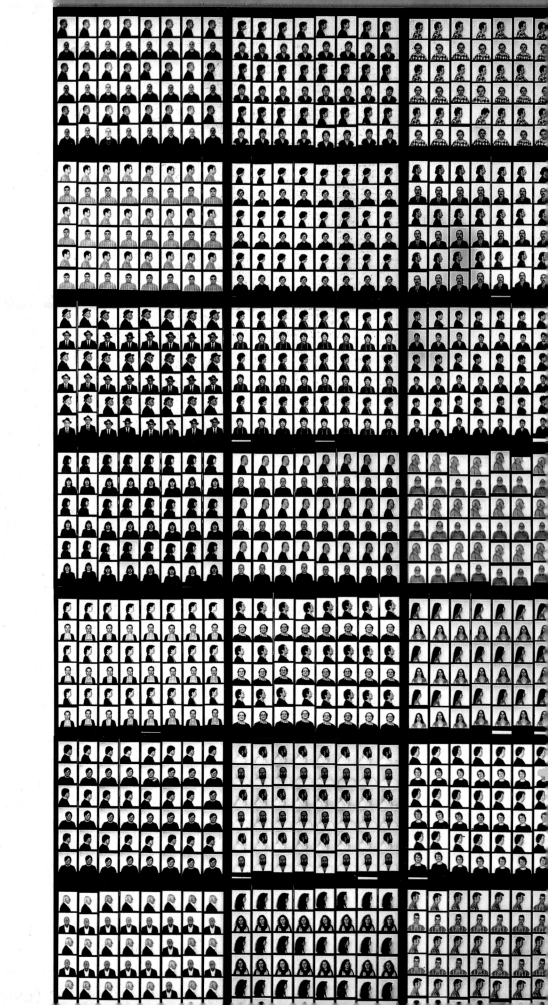

Arnaud Maggs
48 Views Series, 1981-83
*(detail and installation view
at ICP Midtown)*

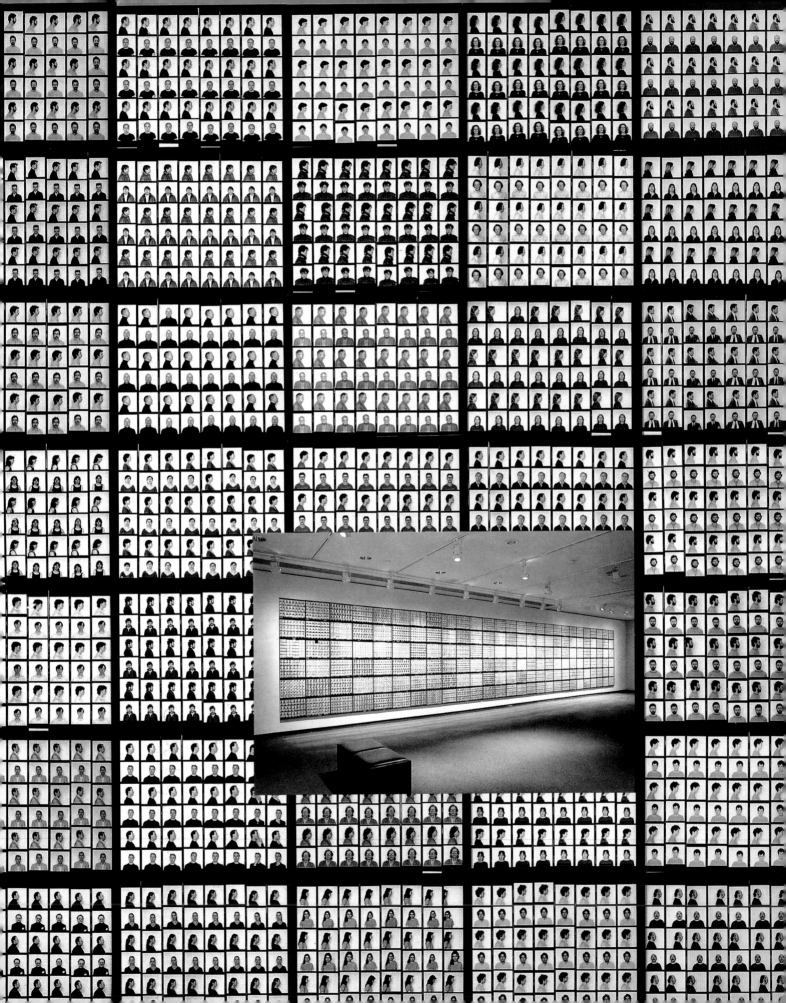

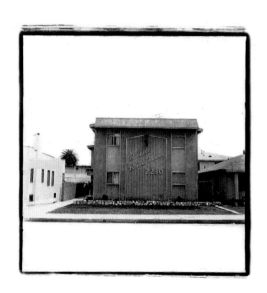 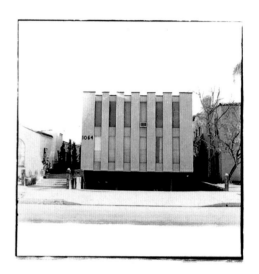

Judy Fiskin
Geometric Facades
from the *Dingbat* series, 1983

John Baldessari
4 Types of Chaos/4 Types of Order, 1984

Robert Heinecken
T.V. Newswomen, 1986

Neil Winokur
Cindy Sherman: Totem, 1986

Garry Fabian Miller
Honesty. The fertile months,
the greening, the growing,
the dying, the seeded hope,
Lowfield Farms, Lincolnshire,
May – September, 1985 (detail)

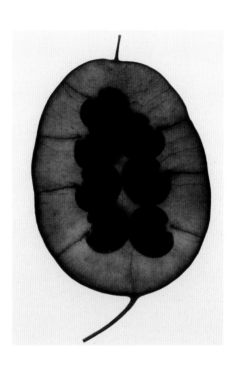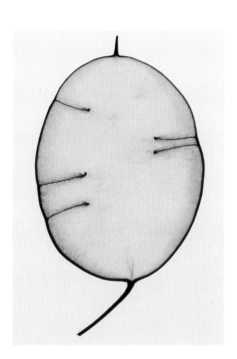

Rick Hock
Codex (Pee Wee), 1988

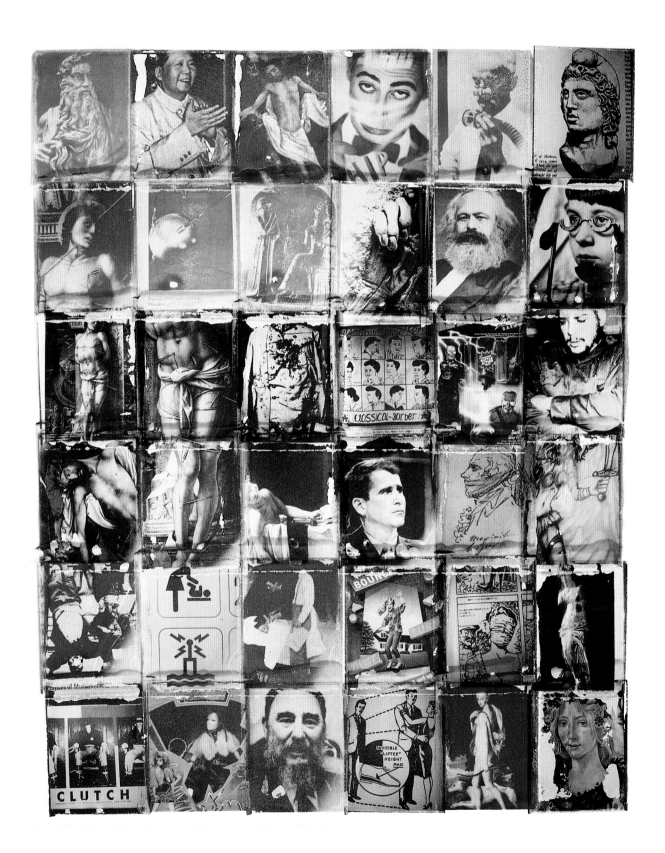

Sarah Charlesworth
Subtle Body, 1989

*Prices of commercial flowers
are influenced by seasonal avail-
ability, packaging or transporta-
tion requirements, and breeding
factors. Higher on the pyramid
are costlier flowers; species
with shorter growing seasons,
fragile blossoms needing spe-
cial protective packaging,
imports from overseas, or flow-
ers from plants requiring much
cultivation but yielding small
harvests. Lower-ranked are the
less expensive flowers; domes-
tic, hardy, high-yield plants with
long growing seasons.*

– Susan Eder

Susan Eder
Flower Value Scale (Price Pyramid), 1989

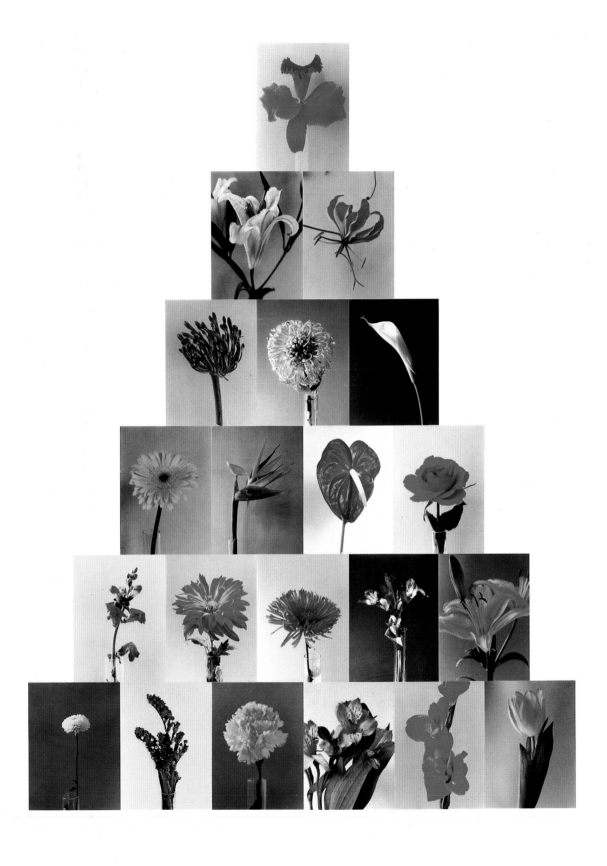

It is true that, particularly since My Wishes (1988) I have turned back again to my early enthusiasms. I am again doing hundreds of coloured drawings similar to those in Collections, but I use them for superimpositions, I pile them up; there are frames covering other frames... The same hand, nose or profile is accumulated and multiplied, until the negative is almost worn out. This again corresponds to the notion of an endless collection based on one sixtieth of a second... Nowadays, "proper" photographers go in for single prints, they mimic painters. What interests me in photography is not the texture, the quality of the surface, or any strictly photographic quality. It is the amazing potential of being able to repeat one and the same image an infinite number of times. In that sense, we have all learned from Warhol.

– Annette Messager

Excerpt of the interview, "Annette Messager or the Taxidermy of Desire," by Bernard Marcadé from the exhibition catalog, "Annette Messager: comédie tragédie 1971-1989," Musée de Grenoble, France, 1989, pp. 173-174.

Annette Messager
Mes Voeux (My Wishes), 1989-90

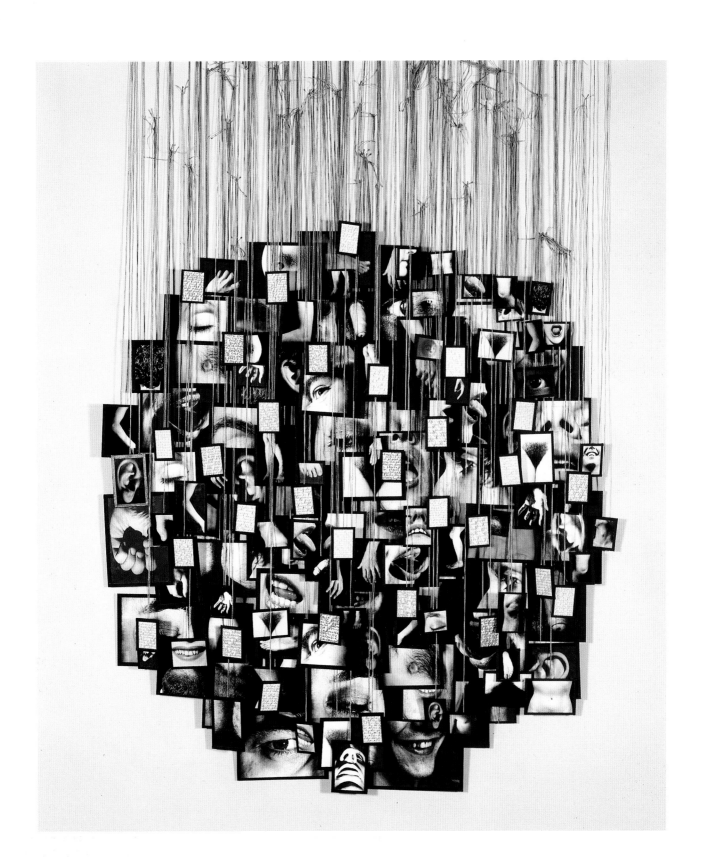

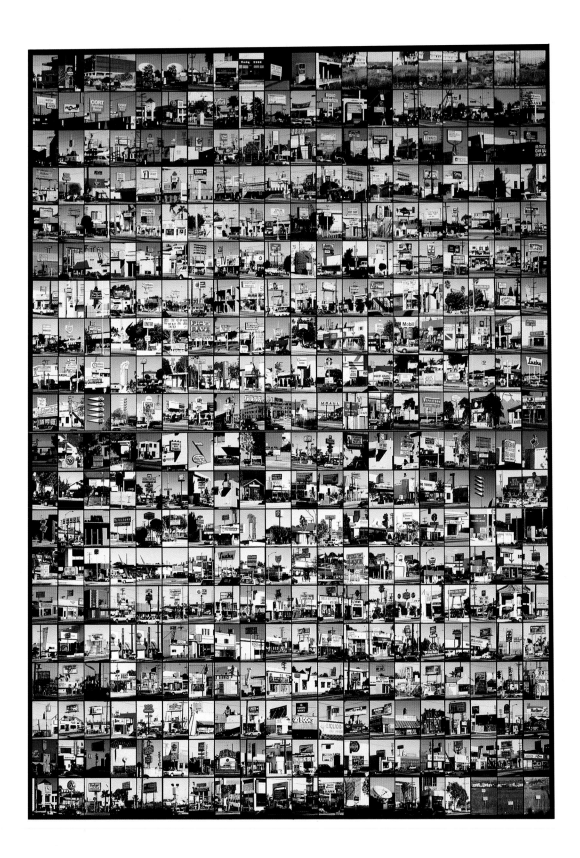

Louise Lawler
Collage/Cartoon, 1990

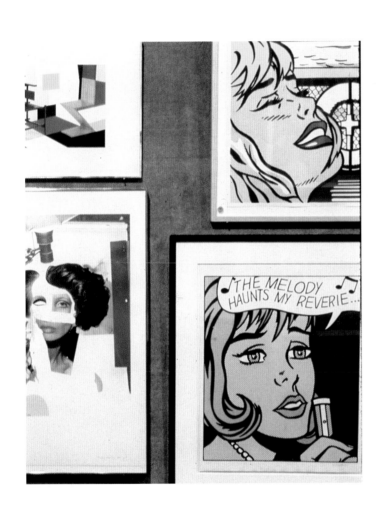
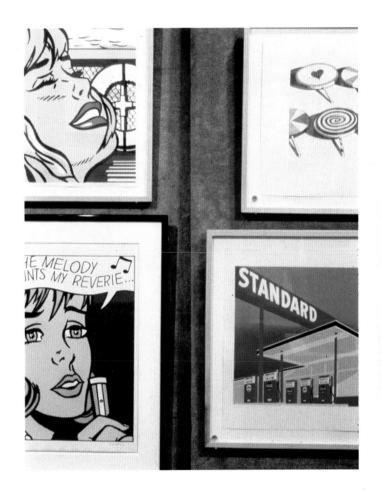

*I was in camera. A point of law.
Something to do with privacy. I
was working at Time-Life. A
large building. A large camera.
Time-Life, a large name. Lip-ser-
vice and animated existence.
Things moving. I was moving.
Away from anything that I made.
I moved to Time-Life. Around
1976. I had turned part of a
storeroom where I worked into a
kind of lunchtime studio. I
started photographing the mag-
azines Time-Life published. I
thought of the camera as an
electronic scissor. I worked in a
department called "tear
sheets." Apart from anyone.
With nothing else besides.
There was really nothing to
mention. I was alone for eight to
twelve hours a day. Tearing up
magazines. Page by page. I was
supposed to tear out all the
editorial pages. Those were
called "hard copies." We
passed along these copies to
the people who wrote the
"copy." To the authors. I was
left with the rest of the maga-
zine. The advertisements. The
authorless pages.*

– Richard Prince

Excerpt of an interview with Richard
Prince by Larry Clark in the exhibition
catalogue, "Richard Prince," Whitney
Museum of American Art, New York
City, 1992, p. 129.

Richard Prince
Untitled (Palms and Decals), 1990

Mitchell Syrop
RFG Constellation #6, 1991-92

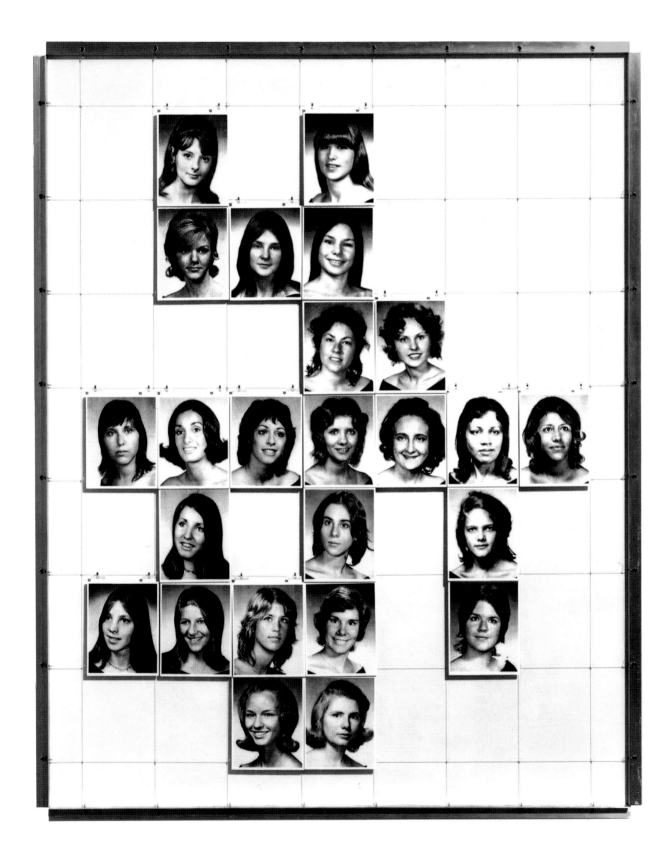

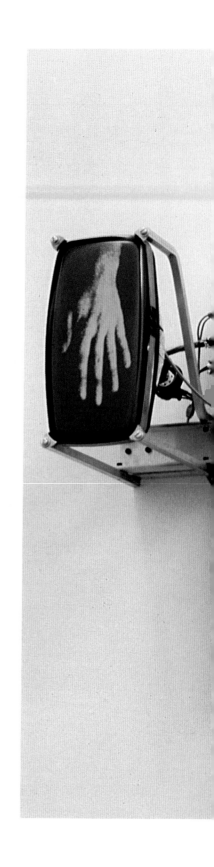

Alan Rath
One O'Clock, 1990

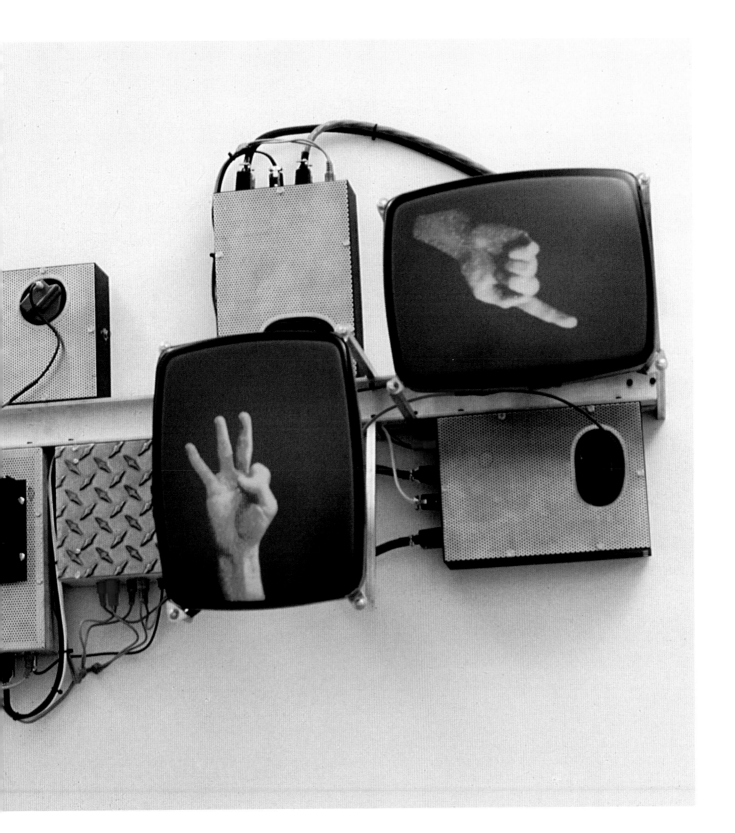

Most of the photographs reproduced in this catalogue have been provided by the artists or by the collections indicated on the exhibition checklist. We thank them for their generosity and would like to acknowledge the following for their contributions as well: Blum Helman Gallery, New York City, p.7; Nelson-Atkins Museum of Art, Kansas City, Missouri (Gift of the Guild of the Friends of Art and a group of friends of the Gallery), p.8; The Lane Collection—Photo, Courtesy, Museum of Fine Arts, Boston, p.9; Estate of Robert Smithson, courtesy John Weber Gallery, New York City, p.11; New York Public Library, p.14; The Andy Warhol Foundation, p.17; David Lubarsky, pp. 22, 23, 29, 31, 33, 45; William Nettles for The Capital Group Foundation, p.41; David Spear, p.49; Galerie Crousel-Robelin Bama, Paris, p.55.

DENNIS ADAMS

Patricia Hearst – A to Z, 1979-89
26 two-color silkscreen prints,
20 x 16 in. ea., 80 x 128 in. overall
Courtesy Kent Gallery, Inc.,
New York City

JOHN BALDESSARI

The Telephone Book (with Pearls),
1988
Offset lithographic book, 68 pp.,
8 ¼ x 5 ¾ in.
Collection International Center of
Photography, New York City

4 Types of Chaos/4 Types of Order,
1984
8 gelatin silver prints with pencil,
74 ¾ x 59 ½ in.
Collection The Capital Group
Foundation, Los Angeles

**Horizontal Men (with One
Luxuriating),** 1984
Gelatin silver prints, 61 ¼ x 49 ¼ in.
Private Collection, courtesy
Sonnabend Gallery, New York City

Brutus Killed Caesar, 1976
Published by The Emily H. Davis Art
Gallery of The University of Akron,
Ohio in cooperation with Sonnabend
Gallery, New York City
Offset lithographic book, 72 pp.,
3 ¾ x 10 ¾ in.
Collection Visual Studies Workshop,
Rochester, New York

Four Events and Reactions, 1975
Published on the occasion of the
exhibition held at the Stedelijk
Museum, Amsterdam,
November 21, 1975 –
January 4, 1976
Offset lithographic book, 24 pp.,
5 x 7 in.
Collection Franklin Furnace Archive,
New York City

**Throwing a Ball Once to Get Three
Melodies and Fifteen Chords,** 1973
Offset lithographic book, 32 pp.,
8 x 10 in.
Collection International Center of
Photography, New York City

BERND & HILLA BECHER

Typology Watertowers, 1972
9 gelatin silver prints, 16 x 12 in. ea.,
48 x 36 in. overall
Sonnabend Collection, New York City

Typology Watertowers, 1972
9 gelatin silver prints, 16 x 12 in. ea.,
48 x 36 in. overall
Sonnabend Collection, New York City

CHRISTIAN BOLTANSKI

**Inventory of objects belonging to a
young woman of Charleston,** 1991
Published by Spoleto Festival U.S.A.
in conjunction with the exhibition,
"Places With a Past: New Site-
Specific Art in Charleston,"
May 24 – August 4, 1991
Offset lithographic book, 50 pp.,
8 ¼ x 5 ½ in.
Collection International Center of
Photography, New York City

**Inventaire des objets ayant
appartenu à une femme de Bois-
Colombes, (Inventory of objects
belonging to a woman of Bois-
Colombes),** 1974

Published in conjuntion with the
exhibition, "Boltanski – Monory,"
October 15 – December 2, 1974,
Centre national d'art contemporain,
Paris
Offset lithographic book, 44 pp.,
8 ¼ x 5 ½ in.
Collection International Center of
Photography, New York City

**The 62 members of the Mickey
Mouse Club in 1955,** 1972
62 gelatin silver prints,
12 x 8 ¾ in. ea., 72 x 87 ½ in. overall
Sonnabend Collection, New York City

SARAH CHARLESWORTH

Subtle Body, 1989
Laminated Cibachrome print,
78 x 57 in.
Courtesy the artist and Jay Gorney
Modern Art, New York City

SUSAN EDER

Fish Value Scale (Price Pyramid),
1991
Ektacolor print, 36 x 48 in.
Courtesy Jones Troyer Fitzpatrick
Gallery, Washington, D.C.

Flower Value Scale (Price Pyramid),
1989
Ektacolor print, 40 x 32 in.
Courtesy Jones Troyer Fitzpatrick
Gallery, Washington, D.C.

JUDY FISKIN

Elaboration of a Square, from the
Dingbat series, 1983
4 gelatin silver prints, 10 x 8 in. ea.,
40 x 8 in. overall
Courtesy the artist

Geometric Facades, from the
Dingbat series, 1983
8 gelatin silver prints, 10 x 8 in. ea.,
22 x 40 in. overall
Courtesy the artist

Peaked Roofs, from the *Dingbat*
series, 1983
4 gelatin silver prints, 10 x 8 in. ea.,
10 x 34 in. overall
Courtesy the artist

ROBBERT FLICK

**One Thousand Signs – along Lincoln
Blvd. looking East. Culver to Wilshire
to Culver, (7:30am-5:15pm),** 1990
Cibachrome print, 36 x 28 in.
Courtesy the artist and Turner/Krull
Gallery, Los Angeles

Silver Saddle Ranch, 1982
Gelatin silver print, 30 x 36 in.
Courtesy the artist and Turner/Krull
Gallery, Los Angeles

ROBERT HEINECKEN

T.V. Newswomen, 1986
12 Cibachrome prints,
78 x 38 in. overall
Collection Continental Insurance,
courtesy Douglas Drake Gallery,
New York City

**1984: A Case Study in Finding an
Appropriate TV Newswoman (A CBS
Docudrama in Words and Pictures),**
1985
Offset lithographic book, 16 pp.,
11 ¼ x 9 in.
Collection International Center of
Photography, New York City

RICK HOCK

Codex (Commerce), 1989
Polaroid transfers, 68 x 53 in.
Courtesy the artist

Codex (Pee Wee), 1988
Poloroid transfers, 22 x 36 in.
Courtesy the artist

DOUGLAS HUEBLER

**Variable Piece no.70 (In Process)
Global 598,** 1975
Diptych with gelatin silver prints and
text, left panel: 37 x 36 ¾ in.;
right panel: 37 x 37 in.
Courtesy Holly Solomon Gallery,
New York City

**Variable Piece no.70 (In Process)
Global 81,** 1973
Acrylic on paper, gelatin silver prints
and text, 48 ¾ x 45 ¾ in.
Courtesy Holly Solomon Gallery,
New York City

Duration Piece #8 Global (Part I & Part II), 1970-73
Offset lithographic book, 50 pp.,
16 x 11 ½ in.
Collection Franklin Furnace Archive,
New York City

Location Piece #2, July 1969
Offset lithographic book in envelope,
19 pp., 7 x 7 in.
Collection International Center of
Photography, New York City

ALLAN KAPROW

Days Off: A Calendar of Happenings, 1970
Commissioned by the Junior Council
of The Museum of Modern Art,
New York
Offset lithography, 15 ⅛ x 10 ¾ in.
Collection International Center of
Photography and courtesy Barbara
Moore/Bound & Unbound,
New York City

Routine, 1975
Offset lithographic book, 4 pp.,
11 x 8 ½ in.
Collection Franklin Furnace Archive,
New York City

LOUISE LAWLER

Collage/Cartoon, 1990
Cibachrome print triptych, each panel
17 ¼ x 24 in.,
17 ¼ x 72 in. overall
Courtesy Metro Pictures,
New York City

SOL LEWITT

Brick Wall, 1977
Offset lithographic book, 32 pp.,
10 ¼ x 8 ¾ in.
Collection International Center of
Photography, New York City

Photogrids, 1977
9 Ektacolor prints from the series,
15 ¼ x 23 ¾ in. ea.
Collection the New Britain Museum
of American Art, Connecticut

From Monteluco to Spoleto,
December 1976
Offset lithographic book, 38 pp.,
10 x 10 in.

Collection International Center of
Photography, New York City

ARNAUD MAGGS

48 Views Series, 1981-83
162 gelatin silver prints,
16 x 20 in. ea., 162 x 372 in. overall
Courtesy the artist

ANNETTE MESSAGER

Mes Voeux (My Wishes), 1989-90
Gelatin silver prints, texts and string,
49 ¼ in. radius
Anne & William J. Hokin Collection

RAY METZKER

Telephone Booth, 1966
Gelatin silver print, 30 x 22 in.
Courtesy Laurence Miller Gallery,
New York City

GARRY FABIAN MILLER

**Co-existence
Human Air Parasite Sun
Vein Leaf Tree Breath
Fragile,**
Torn sycamores, Pusto Wood,
the Trent Valley, Nottinghamshire,
Spring 1986 – Summer 1988
Cibachrome print, 48 x 72 in.
Courtesy the artist

Honesty. The fertile months, the greening, the growing, the dying, the seeded hope,
Lowfield Farms, Lincolnshire,
May – September, 1985
Cibachrome prints, 5 panels,
53 x 15 in. ea., 53 x 100 in. overall
Courtesy the artist

PHOTOGRAPHER UNKNOWN

16 Baseball Players, 1962
Rocky Colavito, Pete Ward, Bob
Allison, Ken Boyer, Frank Robinson,
Sandy Koufax, Willie Mays, Roger
Maris, Al Kaline, Whitey Ford, Jim
Gentile, Bill Mazeroski, Ernie Banks,
Warren Spahn, Mickey Mantle,
Don Drysdale
16 photo-lithographic reproductions

with laminated phonograph recording,
6 ¾ x 6 ¾ in. ea., 27 x 27 in. overall
Private Collection

RICHARD PRINCE

Untitled (Palms and Decals), 1990
Ektacolor print, 86 x 46 in.
Collection Continental Insurance,
courtesy Douglas Drake Gallery,
New York City

ALAN RATH

†***One O'Clock,*** 1990
Aluminum, electronics, cathode ray
tubes, 27 x 40 x 12 in.
Collection Carol and David Dorsky

EDWARD RUSCHA

Babycakes with Weights, 1970
Offset lithographic book, 54 pp.,
7 ½ x 6 in.
Courtesy Marian Goodman Gallery,
New York City

Nine Swimming Pools and a Broken Glass, 1968
Offset lithographic book, 64 pp.,
7 x 5 ½ in.
Collection Visual Studies Workshop,
Rochester, New York

Every Building on the Sunset Strip,
1966
Offset lithographic, accordion-fold
book, 7 ⅛ x 291 ½ in.
Collection International Center of
Photography, New York City

Some Los Angeles Apartments,
1965
Offset lithographic book, 48 pp.,
7 x 5 ½ in., third edition, 1970
Collection Visual Studies Workshop,
Rochester, New York

Various Small Fires and Milk, 1964
Offset lithographic book, 48 pp.,
7 x 5 ½ in., second edition, 1970
Collection Visual Studies Workshop,
Rochester, New York

Twenty-Six Gasoline Stations, 1962
Offset lithographic book, 48 pp.,
7 x 5 ½ in., third edition, 1969
Collection Visual Studies Workshop,
Rochester, New York

MITCHELL SYROP

RFG Constellation #6, 1991-92
Laser prints, aluminum extrusion
and monofilament support structure,
81 x 67 in.
Courtesy the artist and Rosamund
Felsen Gallery, Los Angeles

RFG Constellation #3, 1976-92
Laser prints, aluminum extrusion
and monofilament support structure,
63 x 91 in.
Courtesy the artist and Rosamund
Felsen Gallery, Los Angeles

ANDY WARHOL

Crowd, 1963
Silkscreen ink on canvas, 50 x 36 ⅛ in.
Courtesy Galerie Bruno
Bischofberger, Zurich

ROBERT WATTS

†***Chest of Moles, (Portrait of Pamela),*** 1965–85
Photo-embedments in plastic,
illuminated glass and wood case,
17 x 13 x 7 ¾ in.
Courtesy Larry Miller and Sara
Seagull, the Robert Watts Studio
Archive, New York City

FLUXPOST 17-17, 1964
2 stamp sheets (black and blue),
11 x 8 ½ in. ea.
Courtesy Larry Miller and Sara
Seagull, the Robert Watts Studio
Archive, New York City

YAMFLUG/5 POST 5, 1963
2 stamp sheets (red and green),
10 ½ x 8 ¼ in. ea.
Courtesy Larry Miller and Sara
Seagull, the Robert Watts Studio
Archive, New York City

NEIL WINOKUR

Cindy Sherman: Totem, 1986
5 Cibachrome prints,
20 ½ x 16 ½ in. ea.,
61 ½ x 49 ½ in. overall
James K. Patterson Collection

† Not included in traveling exhibition

DENNIS ADAMS

Born 1948, Des Moines, Iowa

Resides New York City

SELECTED SOLO EXHIBITIONS AND PUBLIC WORKS

1992 Galerie Franck & Schulte, Berlin; "Arcadian Blind," Floriadepark, Zoetermeer, Holland (public work)

1991 The Museum of Modern Art, New York City; Orangerie, Englishcher Garten, Munich; "Emancipation," Boston (public work)

1990 Kent Fine Art, New York City; Hirshhorn Museum and Sculpture Garden, Smithsonian Institution, Washington, D.C.; "Bus Shelter V & VI," Essen, Germany (public work)

1989 Galerie Meert-Rihoux, Brussels; "Ticket Booth," Whitney Museum of American Art, New York City (public work)

1988 de Appel Foundation, Amsterdam; "Bus Shelter VII," C.W. Post Campus of Long Island University, Brookville, New York (public work); "Public Commands/Other Voices," Martin Luther King Jr. Metrorail Station, Miami, Florida (public work)

1986 Nature Morte Gallery, New York City; "Bus Shelter I," 14th Street and 3rd Avenue, New York City (public work)

1984 The Kitchen, New York City

1983 "Bus Shelter I," Broadway and 66th Street, New York City (public work)

1978 "Patricia Hearst—A Second Reading," 10 on 8, New York City (public work)

1975 Wright State University, Dayton, Ohio; Carl Solway Gallery, Cincinnati, Ohio

1972 Akron Art Institute, Ohio

SELECTED GROUP EXHIBITIONS

1992 "Notes from the Material World: Contemporary Photomontage," John Michael Kohler Arts Center, Sheboygan, Wisconsin;

"Pour la suite du Monde," Musée d'Art Contemporain de Montréal

1991 "The Political Arm," John Weber Gallery, New York City; "Power: Its Myths, Icons, & Structures in American Culture, 1961-1991," Indianapolis Museum of Art; "Artists of Conscience: 16 Years of Social and Political Commentary," Alternative Museum, New York City

1990 "Insect Politics: Body Horror/Social Order," Hallwalls, Buffalo, New York; "Passages de l'image," Musée National d'Art Moderne, Centre Georges Pompidou, Paris (traveling exhibition); "The Decade Show: Frameworks of Identity in the 80's," The Studio Museum in Harlem, New York City

1989 "Sequence (Con)Sequence: (Sub)Versions of Photography in the 80s," Edith C. Blum Institute, Bard College, Annandale-on-Hudson, New York; "Not Photography," Meyers/Bloom Gallery, Santa Monica, California; "Image World: Art and Media Culture," Whitney Museum of American Art, New York City

1988 "Constructions: Between Sculpture and Architecture," Sculpture Center, New York City; "Public Discourse," Real Artways, Hartford, Connecticut

1987 "Spectre of Saturation," McIntosh/Drysdale Gallery, Washington, D.C.; "Art in the Dark," City Without Walls, Newark, New Jersey

1986 "Uplifted Atmospheres, Borrowed Taste," Hallwalls, Buffalo, New York

1985 "The Artist as Social Designer: Aspects of Urban Art Today," Los Angeles County Museum of Art; "Disinformation: The Manufacture of Consent," Alternative Museum, New York City; "Art on the Beach," Battery Park City Landfill, New York City

1984 "Contemporary Perspectives 1984," Center Gallery, Bucknell University, Lewisberg, Pennsylvania and Sordoni Art Gallery, Wilkes College, Wilkes-Barre, Pennsylvania

1981 "Libres d'artista/Artists' Books," El Centre de Documentacio d'Art Actual, Metronom, Barcelona

1980 "Sound, Space and Performance," Miami University, Oxford, Ohio

1979 "Reality of Illusion," Denver Art Museum, Colorado (traveling exhibition)

JOHN BALDESSARI

Born 1931, National City, California

Resides Santa Monica, California

SELECTED SOLO EXHIBITIONS

1991 Donald Young Gallery, Chicago; Galerie Crousel-Robelin Bama, Paris

1990 "John Baldessari," The Museum of Contemporary Art, Los Angeles (traveling exhibition); Sonnabend Gallery, New York City

1989 "Ni Por Esas – Not Even So: John Baldessari," Centro de Arte Reina Sofía, Madrid

1988 "John Baldessari: Recent Work," Margo Leavin Gallery, Los Angeles; "John Baldessari: Oeuvres recentes," Galerie Laage-Salomon, Paris; Lisson Gallery, London

1987 Centre National d'Art Contemporain de Grenoble, France; Sonnabend Gallery, New York City

1986 "John Baldessari: Matrix Berkeley 94," University Art Museum, University of California, Berkeley

1984 Sonnabend Gallery, New York City; Galerie Gillespie-Laage-Salomon, Paris

1982 The Contemporary Arts Center, Cincinnati, Ohio; Contemporary Arts Museum, Houston, Texas

1980 "Fugitive Essays," Sonnabend Gallery, New York City

1977 "Matrix," Wadsworth Atheneum, Hartford, Connecticut

1975 Stedelijk Museum, Amsterdam

1973 Sonnabend Gallery, New York City

1971 Art and Project, Amsterdam

1966 La Jolla Museum of Contemporary Art, California

SELECTED GROUP EXHIBITIONS

1991 "Breakthroughs: Avant-Garde Artists in Europe and America, 1950-1990," Wexner Center for the Arts, The Ohio State University, Columbus; "Devil on the Stairs: Looking Back on the Eighties," Institute of Contemporary Art, University of Pennsylvania, Philadelphia

1990 "Word as Image: American Art 1960-1990," Milwaukee Art Museum, Wisconsin (traveling exhibition)

1989 "LA Pop in the Sixties," Newport Harbor Art Museum, Newport Beach, California; "Invention and Continuity in Contemporary Photographs," The Metropolitan Museum of Art, New York City; "California Photography: Remaking the Make-Believe," The Museum of Modern Art, New York City

1988 "Modes of Address: Language in Art Since 1960," Whitney Museum of American Art Downtown, New York City

1987 "Avant-Garde in the Eighties," Los Angeles County Museum of Art

1985 "1985 Biennial," Whitney Museum of American Art, New York City; "1985 Carnegie International," The Carnegie Museum of Art, Pittsburgh, Pennsylvania

1981 "The Museum as Site: Sixteen Artists," Los Angeles County Museum of Art; "Instant Photography," Stedelijk Museum, Amsterdam

1980 "Visual Articulation of Idea," Visual Studies Workshop, Rochester, New York

1978 "American Narrative/Story Art: 1967-1977," Contemporary Arts Museum, Houston, Texas; University Art Museum, University of California, Berkeley

1976 "Rooms," P.S. 1, Long Island City, New York; "Artists Use Photography," Hallwalls, Buffalo, New York

1974 "Project '74," Cologne, West Germany

1972 "Documenta 5," Museum Fridericianum, Kassel, West Germany

1970 "Art in the Mind," Oberlin College, Ohio; "Information," The Museum of Modern Art, New York City

1969 "Art by Telephone," Museum of Contemporary Art, Chicago

BERND & HILLA BECHER

BERND: Born 1931, Siegen District, Germany

Resides Düsseldorf, Germany

HILLA: Born 1934, Berlin

Resides Düsseldorf, Germany

SELECTED SOLO EXHIBITIONS

1992 Daniel Weinberg Gallery, Santa Monica, California

1991 Galerie Max Hetzler, Cologne, Germany; Primo Piano, Rome

1990 Sonnabend Gallery, New York City

1989 "American Buildings and Others," Urbi et Orbi Galerie, Paris

1988 "Hauser," Bei Konrad Fischer, Düsseldorf, West Germany; "Watertowers," Kunstverein Munich; Palais des Beaux Arts, Brussels

1986 Carnegie Mellon Art Gallery, Carnegie Mellon University, Pittsburgh, Pennsylvania; Kamakura Gallery, Chuo-ku, Tokyo

1985 Folkwangmuseum, Essen, West Germany; ARC, Musée d'Art Moderne de la Ville de Paris

1983 Freedman Gallery, Reading, Pennsylvania; Sonnabend Gallery, New York City

1982 Carol Taylor, Dallas, Texas

1981 Kunstverein, Seigen, West Germany; "Retrospective Exhibition," Stedelijk Van Abbemuseum, Eindhoven, The Netherlands

1980 Fach Hochschule und

Hochschule fur Bildende Kunste, Hamburg, West Germany; Galerie Vega, Liège, Belgium

1979 Galerie Sonnabend, Paris

1977 InK, Crex Collection, Zurich, Switzerland

1975 The Museum of Modern Art, New York City

1974 Wadsworth Atheneum, Hartford, Connecticut

1972 International Museum of Photography at George Eastman House, Rochester, New York

1970 Moderna Museet, Stockholm, Sweden

1968 Stedelijk Van Abbemuseum, Eindhoven, The Netherlands; Galerie Ruth Nohl, Seigen, West Germany

1967 Kunstakademie, Copenhagen, Denmark

1963 Galerie Ruth Nohl, Seigen, West Germany

SELECTED GROUP EXHIBITIONS

1992 "L'esprit de l'industrie," Collection du CAPC, CAPC, Musée d'Art Contemporain, Bordeaux, France; "Photography in Contemporary German Art: 1960 to the Present," Walker Art Center, Minneapolis, Minnesota (traveling exhibition)

1991 "Typologies: Nine Contemporary Photographers," Newport Harbor Art Museum, Newport Beach, California (traveling exhibition)

1990 "Assembled: Works of Art Using Photography as a Construction Element," Museum of Contemporary Art at Wright State University, Dayton, Ohio; "Signs of Life: Process and Materials, 1960-1990," Institute of Contemporary Art, University of Pennsylvania, Philadelphia; "Venice Biennale," Italy

1989 "Repetition," Hirschl & Adler Modern, New York City; "Bilderstreit: construction, unity and fragmentation in art since 1960," Ludwig Museum in the Rheinhallen, Cologne, West Germany

1987 "This is Not a Photograph: 20 Years of Large-Scale Photography,

1966-1986," John and Mable Ringling Museum of Art, Sarasota, Florida

1986 "Bernd & Hilla Becher, Gunther Forg, Reinhard Mucha," Luhring, Augustine & Hodes Gallery, New York City

1984 "Artistic Collaboration in the Twentieth Century," Hirshhorn Museum and Sculpture Garden, Smithsonian Institution, Washington, D.C.

1983 "Big Pictures by Contemporary Photographers," The Museum of Modern Art, New York City

1982 "Visual Cataloguing & Mapping: Photographs, Installations & Artist's Books," Visual Studies Workshop, Rochester, New York

1980 "Europe 1980," Lyon, France; "Artist and Camera," Arts Council, Great Britain

1977 "Documenta 6," Museum Fridericianum, Kassel, West Germany; "Internationale Biennale Sao Paulo," Brazil

1975 "New Topographics: Images of a Man-Altered Landscape," International Museum of Photography at George Eastman House, Rochester, New York

1974 "Idea and Image," The Art Institute of Chicago

1972 "Documenta 5," Museum Fridericianum, Kassel, West Germany

1970 "Information," The Museum of Modern Art, New York City

CHRISTIAN BOLTANSKI

Born 1944, Paris

Resides Malakoff, France

SELECTED SOLO EXHIBITIONS

1992 Gallery Senda, Hiroshima, Japan

1991 "The Dead Swiss," Marian Goodman Gallery, New York City; "Reconstitution," Musée de Grenoble, France

1990 "Réserve," Galerie Elisabeth Kaufmann, Basel, Switzerland; The Institute of Contemporary Art, Nagoya, Japan; "Meurtre," Beaux-Arts Galerij, Brussels

1989 "Archives," Galerie Ghislaine Hussenot, Paris

1988 "Lessons of Darkness," Museum of Contemporary Art, Chicago, The Museum of Contemporary Art, Los Angeles, and The New Museum of Contemporary Art, New York City

1987 "Oeuvres inédites," Galerie Roger Pailhas, Marseille, France; "Monuments," Galerie Chantal Boulanger, Montreal

1986 "Peindre photographier," Galerie des Ponchettes, Musée de Nice, France; "Monuments," Galerie Crousel-Hussenot, Paris; Art Space, Sydney, Australia

1984 "Shadows," Galerie 't Venster, Rotterdam, The Netherlands

1982 Sonnabend Gallery, New York City; Nouveau Musée, De Vleeshal, Middelburg, The Netherlands

1980 "Christian Boltanski-compositions," Musée des Beaux-Arts, Calais, France

1979 Sonnabend Gallery, New York City

1978 "Compositions photographiques," Galerie Jöllenbeck, Cologne, West Germany; P.S. 1, Long Island City, New York

1977 "Stories and Posters," La Jolla Museum of Contemporary Art, California

1976 "Photographies couleurs-Images modèles," Musée National d'Art Moderne, Centre Georges Pompidou, Paris

1975 Centre d'Art Contemporain, Geneva

1974 "Les Inventaires," Louisiana Museum, Humlebaek, Denmark

1973 "Les Inventaires," Museum of Modern Art, Oxford, England

1971 "Essais de reconstitution d'objets ayant appartenu à Christian Boltanski entre 1948-1954," Galerie Sonnabend, Paris

SELECTED GROUP EXHIBITIONS
1991 "1991 Carnegie International," The Carnegie Museum of Art, Pittsburgh, Pennsylvania; "Places with a Past: New Site-Specific Art in Charleston," Spoleto Festival U.S.A., Charleston, South Carolina; "The Anonymous Other," Ansel Adams Center, Friends of Photography, San Francisco

1990 "Stendhal Syndrome: The Cure," Andrea Rosen Gallery, New York City; "Assembled," The University Art Gallery, Wright State University Creative Art Center, Dayton, Ohio

1989 "On the Art of Fixing a Shadow: One Hundred and Fifty Years of Photography," National Gallery of Art, Washington, D.C., and The Art Institute of Chicago; "L'invention d'un art," Musée National d'Art Moderne, Centre George Pompidou, Paris; "L'art sacré," Beaux-Arts Galerij, Brussels

1988 "Saturne en Europe," Musée des Beaux-Arts, Ancienne Douane, Musée de l'Oeuvre Notre Dame, Strasbourg, France; "Art or Nature," Barbican Art Gallery, London

1987 "Die Gleischzeitigkeit des Anderen," Kunstmuseum, Bern, Switzerland; "Documenta 8," Museum Fridericianum, Kassel, West Germany

1986 "Lumières: Perception-Projection," Centre International d'Art Contemporain de Montréal

1985 Galerie Crousel-Hussenot, Paris; "Dialog," Moderna Museet, Stockholm, Sweden

1983 "Kunst mit Fotografie," Nationalgalerie, Berlin

1981 "Westkunst," Museen der Stadt Köln, Cologne, West Germany

1979 "Text-Foto-Geschichten. Story Art/Narrative Art," Bonner Kunstverein, Bonn, West Germany

1978 "Couples," P.S. 1, Long Island City, New York

1977 "Documenta 6," Museum Fridericianum, Kassel, West Germany

1976 "II Triennale of Photography," Israel Museum, Jerusalem

1975 "IXe Biennale de Paris," Musée National d'Art Moderne, Centre Georges Pompidou, Paris; "Venice Biennale," Italy

SARAH CHARLESWORTH

Born 1947, East Orange, New Jersey

Resides New York City

SELECTED SOLO EXHIBITIONS
1992 "Special Project: Herald Tribune: November, 1977; Herald Tribune: June 18-February 28, 1991," The Queens Museum, Flushing, New York

1991 Paley Wright Gallery, London (with Graham Gussin); Jay Gorney Modern Art, New York City

1990 S.L. Simpson Gallery, Toronto

1989 Jay Gorney Modern Art, New York City; Interim Art, London

1988 Gallery Hufkens Noirhomme, Brussels

1987 Margo Leavin Gallery, Los Angeles (with Joel Otterson)

1986 S.L. Simpson Gallery, Toronto

1985 California Museum of Photography, University of California, Riverside

1984 Light Work, Syracuse, New York; The Clocktower Gallery, New York City

1982 Larry Gagosian, New York City; CEPA Gallery, Buffalo, New York

1981 Galerie Micheline Scwajcer, Antwerp, Belgium

1980 Tony Shafrazi Gallery, New York City

SELECTED GROUP EXHIBITIONS
1992 "Knowledge: Aspects of Conceptual Art," University Art Museum, University of California, Santa Barbara

1991 "The Interrupted Life," The New Museum of Contemporary Art, New

York City; "Motion and Document-Sequence and Time: Eadweard Muybridge and Contemporary American Photography," Addison Gallery of American Art, Andover, Massachusetts (traveling exhibition)

1990 "Figuring the Body," Museum of Fine Arts, Boston; "The Indomitable Spirit," organized by Photographers + Friends United Against AIDS, International Center of Photography Midtown, New York City

1989 "Image World: Art and Media Culture," Whitney Museum of American Art, New York City; "Culture Medium," International Center of Photography, New York City; "A Forest of Signs: Art in the Crisis of Representation," The Museum of Contemporary Art, Los Angeles; "The Photography of Invention: American Pictures of the 1980s," National Museum of American Art, Smithsonian Institution, Washington, D.C. (traveling exhibition)

1988 "Female (Re)production," White Columns, New York City; "Biennale of Sydney," Australia

1987 "Monsters: The Phenomena of Dispassion," Barbara Toll Fine Arts, New York City; "The Surrealist Legacy in Post Modern Photography," Alternative Museum, New York City

1986 "Infotainment," Vanguard Gallery, Philadelphia, Pennsylvania; "Venice Biennale," Italy

1985 "Selected Artists from the East Village," Holly Solomon Gallery, New York City; "Playing It Again, Strategies of Appropriation," The Institute for Contemporary Arts, Santa Fe, New Mexico; "1985 Biennial," Whitney Museum of American Art, New York City; "The Art of Memory, The Loss of History," The New Museum of Contemporary Art, New York City

1984 "The Magazine Store," Washington Project for the Arts, Washington, D.C.; "Sex Specific: Photographic Investigations of Contemporary Sexuality," School of the Art Institute of Chicago Gallery

1983 Palais des Beaux Arts, Brussels; "Art and Social Change, U.S.A.," Allen Memorial Art Museum, Oberlin College, Ohio

1982 "State of the Art, The New Social Commentary," Barbara Gladstone Gallery, New York City

1981 "Photo," Metro Pictures, New York City; "New York, New Wave," P.S. 1, Long Island City, New York

1980 "Artemesia," Paula Cooper Gallery, New York City

1978 Bibliothèque Nationale, Paris

1976 Galerie Durand-Desert, Paris

SUSAN EDER

Born 1950, St. Louis, Missouri

Resides Falls Church, Virginia

SELECTED SOLO EXHIBITIONS
1991 Jones Troyer Fitzpatrick Gallery, Washington, D.C.

1987 Jones Troyer Fitzpatrick Gallery, Washington, D.C.

1985 Fontbonne College, St. Louis, Missouri; College of Saint Rose, Albany, New York

1983 Soroban Gallery, Wellfleet, Massachusetts; "Multiples," Marian Goodman Gallery, New York City

1982 "Multiples," Marian Goodman Gallery, New York City; Siegel Contemporary Art, New York City

1981 Bennington College, Bennington, Vermont; Soroban Gallery, Wellfleet, Massachusetts

1979 Hampshire College, Amherst, Massachusetts

1978 Susan Caldwell Gallery, New York City

1977 Hallwalls, Buffalo, New York

1976 Artists Space, New York City

SELECTED GROUP EXHIBITIONS
1991 "Immagini Proiettate, U.S. and Italian Artists," Viafarini, Milan, Italy

1989 "2 X 10," The Arts Club of Washington, D.C.; "Washington Photographers," Jones Troyer Fitzpatrick Gallery, Washington, D.C.

1988 "Alpha Numerics," Brody's Gallery, Washington, D.C.; "Auction Exhibition," Washington Project for the Arts, Washington, D.C.

1986 "RSM Collection," Cincinnati Art Museum, Ohio; "Frames of Mind," Munson-Williams-Proctor Institute, Utica, New York

1985 "Aspects of New Narrative Art," Skidmore College, Saratoga, New York; "Small Works," New York University, New York City

1984 "Multiple Images," Albany Institute of History and Art, New York; "Common Denominator," State University of New York at Buffalo

1979 "Seven Artists," Williams College Museum of Art, Williamstown, Massachusetts

1978 "Auction Exhibition," Hallwalls, Buffalo, New York

1976 "Surface Appearances," Midtown Y Gallery, New York City

JUDY FISKIN

Born 1945, Chicago

Resides Los Angeles

SELECTED SOLO EXHIBITIONS

1992 "The Photographs of Judy Fiskin," Center for Creative Photography, University of Arizona, Tucson

1991 "Some Art," Asher-Faure Gallery, Los Angeles; "Some Art," Curt Marcus Gallery, New York City

1990 "Recent Work," The Drawing Room, Tucson, Arizona

1988 "Survey, 1973-1988," Newspace, Los Angeles

1987 "My Trip to New York," Mount St. Mary's College, Los Angeles

1986 "My Trip to New York," Newspace, Los Angeles

1985 "New Work," Malinda Watt Gallery, New York City

1984 "Some Aesthetic Decisions," Newspace, Los Angeles

1983 "Dingbat," Paper Architecture, Minneapolis, Minnesota

1982 "Dingbat," Newspace, Los Angeles

1981 "Long Beach," Los Angeles Institute of Contemporary Art; "More Stucco," Otis Art Institute of Parsons School of Design, Los Angeles

1976 "Desert Photographs," Arco Center for Visual Art, Los Angeles

1975 "Thirty-Five Views of San Bernardino," California State University, San Bernardino

SELECTED GROUP EXHIBITIONS

1991 "Typologies: Nine Contemporary Photographers," Newport Harbor Art Museum, Newport Beach, California (traveling exhibition); "The Encompassing Eye: Photography as Drawing," University of Akron, Ohio (traveling exhibition); "Photographing Los Angeles Architecture," Turner/Krull Gallery, Los Angeles; "Death as a Creative Force," Chapman College, Orange, California

1990 "Home," Asher-Faure Gallery, Los Angeles; "Perspectives on Place: Attitudes Toward the Built Environment," University Art Gallery, San Diego State University, California; "Spirit of Our Time," Contemporary Arts Forum, Santa Barbara, California

1989 "Poetic Objectives," Curt Marcus Gallery, New York City; "Stated as Fact: New Jersey Documents," New Jersey State Museum, Trenton; "Framing Four Decades," University Art Museum, California State University, Long Beach

1988 "Democracy," organized by Group Material, Dia Art Foundation, New York City; "A Visible Order," Otis Art Institute of Parsons School of Design, Los Angeles

1987 "Through the Lens: 40 Years of Photography," Fresno Arts Center and Museum, California

1986 Lieberman & Saul, New York City; "A Visible Order," Gallery 400, University of Illinois, Chicago

1985 "On View — New Work Gallery," The New Museum of Contemporary Art, New York City

1984 "Exposed and Developed: Photography Sponsored by the NEA," National Museum of American Art, Smithsonian Institution, Washington, D.C.; "There is No Finish Line," Newspace, Los Angeles

1981 "California: The State of the Landscape (1872-1981)," Newport Harbor Art Museum, Newport Beach, and Santa Barbara Museum of Art, California

1980 "Landscape Images: Recent Photographs by Linda Connor, Judy Fiskin, and Ruth Thorne-Thomsen," La Jolla Museum of Contemporary Art, California

1977 "Los Angeles in the Seventies," Joslyn Art Museum, Omaha, Nebraska; "Several Diverse Photographic Views," San Francisco Camerawork Gallery

1976 "Exposing: Photographic Definitions," Los Angeles Institute of Contemporary Art

1975 "Impetus: The Creative Process," Los Angeles Municipal Art Gallery

1973 "Exposures: Photography and its Extensions," Womanspace Gallery, Los Angeles

ROBBERT FLICK

Born 1939, Amersfoort, Holland

Resides Claremont, California

SELECTED SOLO EXHIBITIONS

1992 Turner/Krull Gallery, Los Angeles

1987 Min Gallery, Tokyo; Tortue Gallery, Santa Monica, California

1984 "Solstice Canon Suite," Tortue Gallery, Santa Monica, California; Light Gallery, New York City

1983 Etherton Gallery, Tucson, Arizona; "The Divided Landscape," Robert Freidus Gallery, New York City

1982 "Robbert Flick, 1971-81," Los Angeles Municipal Art Gallery; Tortue Gallery, Santa Monica, California

1980 Center for Creative Photography, University of Arizona, Tucson

1976 "Robbert Flick," Light Gallery, New York City

SELECTED GROUP EXHIBITIONS

1992 "Between Home and Heaven, Contemporary American Landscape Photography," National Museum of American Art, Smithsonian Institution, Washington, D.C.; "Patterns of Influence," Center for Creative Photography, University of Arizona, Tucson; "the frame: multiplied and extended," South Coast Metro Center, Costa Mesa, California

1991 "Motion and Document-Sequence and Time: Eadweard Muybridge and Contemporary American Photography," Addison Gallery of American Art, Andover, Massachusetts (traveling exhibition)

1990 "Waterworks," Long Beach Museum of Art, California; "Systems," Los Angeles Municipal Art Gallery

1989 "Decade by Decade: Issues in Twentieth Century Photography," Center for Creative Photography, University of Arizona, Tucson

1986 "PHOTOMOSAICS: The Landscape Reconstructed," Photographic Resource Center, Boston University; "Facets of Modernism: Photographs from the San Francisco Museum of Modern Art," San Francisco Museum of Modern Art

1983 "RADICAL/RATIONAL SPACE/TIME: Idea-networks in Photography," Henry Art Gallery, University of Washington, Seattle

1982 "Visual Cataloguing and Mapping: Photographs, Installations & Artist's Books," Visual Studies Workshop, Rochester, New York; "Landscapes 1860-1880, 1960-1980," Oakland Museum of Art, California

1980 "New Landscapes, Part II," Friends of Photography, Carmel, California

1979 "Attitudes: Photography in the 1970's," Santa Barbara Museum of Art, California

1978 "Contemporary California Photography," San Francisco Camerawork Gallery

1974 "New Photographs of Illinois," The Art Institute of Chicago; "Dutton, Flick and Parker," Visual Studies Workshop, Rochester, New York

1973 "L.A. Diary," Madison Art Center, Wisconsin

1972 "Photokina '72," Cologne, West Germany

1966 "Vancouver Between the Eyes," Vancouver Art Gallery, British Columbia, Canada

ROBERT HEINECKEN

Born 1931, Denver, Colorado

Resides Los Angeles

SELECTED SOLO EXHIBITIONS

1992 Pace/MacGill Gallery

1990 "I/You: Dorit Cypis/Robert Heinecken," Walter McBean Gallery, San Francisco Art Institute (two-person exhibition)

1989 Pace/MacGill Gallery, New York City; "Robert Heinecken 1966-1989," Sunnygate Gallery, Taipei, Taiwan

1987 The Art Institute of Chicago

1986 Min Gallery, Tokyo

1983 "John Wood and Robert Heinecken," Los Angeles Center for Photographic Studies (two-person exhibition)

1982 "Robert Heinecken/Joyce Neimanas," Northlight Gallery, School of Art, Arizona State University, Tempe (two-person exhibition)

1981 Light Gallery, New York City

1980 Art Gallery, University of Nevada, Las Vegas

1976 International Museum of Photography at George Eastman House, Rochester (traveling exhibition)

1973 Light Gallery, New York City

1972 University of Rhode Island, Kingston; Pasadena Art Museum, California

1970 Witkin Gallery, New York City; California State College, Northridge

1968 Focus Gallery, San Francisco

1966 Mills College Art Gallery, Oakland, California

1964 Mount St. Mary's College Fine Arts Gallery, Los Angeles

SELECTED GROUP EXHIBITIONS

1991 "With the Media, Against the Media," Long Beach Museum of Art, California

1990 "Photography Until Now," The Museum of Modern Art, New York City (traveling exhibition); "The Indomitable Spirit," organized by Photographers + Friends United Against AIDS, International Center of Photography Midtown, New York City

1989 "On the Art of Fixing a Shadow: One Hundred and Fifty Years of Photography," National Gallery of Art, Washington, D.C., and The Art Institute of Chicago; "Image World: Art and Media Culture," Whitney Museum of American Art, New York City

1988 "John Baldessari/Robert Heinecken/Ed Ruscha," Pace/MacGill Gallery, New York City

1987 "Photography and Art: Interactions Since 1964," Los Angeles County Museum of Art (traveling exhibition)

1986 "Stills: Cinema and Video Transformed," Seattle Art Museum, Washington

1984 "Photography in California: 1945-1980," San Francisco Museum of Modern Art (traveling exhibition)

1983 "Big Pictures by Contemporary Photographers," The Museum of Modern Art, New York City

1982 "Color as Form: A History of Color Photography," International Museum of Photography at George Eastman House, Rochester, New

York; "Target III: In Sequence (Photographic series, sequences and sets from the Target Collection of American Photography)," The Museum of Fine Arts, Houston, Texas

1980 "Photography: Recent Directions," De Cordova Museum and Sculpture Park, Lincoln, Massachusetts

1978 "Mirrors and Windows: American Photography Since 1960," The Museum of Modern Art, New York City

1974 "Rip-Off Exhibition," Visual Studies Workshop, Rochester, New York (traveling exhibition); "Photography in America," Whitney Museum of American Art, New York City

1972 "Photokina '72," Cologne, West Germany

1970 "Photography Into Sculpture," The Museum of Modern Art, New York

1969 "Vision and Expression," International Museum of Photography at George Eastman House, Rochester, New York (traveling exhibition)

1967 "The Persistence of Vision," International Museum of Photography at George Eastman House, Rochester, New York (traveling exhibition)

RICK HOCK

Born 1947, Roswell, New Mexico

Resides Rochester, New York

SELECTED SOLO EXHIBITIONS

1991 "Codices & Cantos," Denver Art Museum, Colorado; Hartnett Gallery, University of Rochester, New York; Houston Center for Contemporary Photography, Texas

1988 "New Codices," International Museum of Photography at George Eastman House, Rochester, New York; "New Dimensions," Clarence Kennedy Gallery, Cambridge, Massachusetts

1987 "Codex," Visual Studies Workshop, Rochester, New York; Hartnett Gallery, University of Rochester, New York

1985 University of Rochester, New York

1983 Creative Photography Gallery, Massachusetts Institute of Technology, Cambridge

1982 University of Dayton Creative Photography Gallery, Ohio

1980 Rochester Institute of Technology, New York

1978 Light Impressions, Rochester, New York

SELECTED GROUP EXHIBITIONS

1992 "Flora Photographica," Montreal Museum of Fine Arts

1989 "Image and Imagination: 150 Years of Photography," The MIT Museum, Massachusetts Institute of Technology, Cambridge; "Nature and Culture, The Inaugural Exhibition," Ansel Adams Center, Friends of Photography, San Francisco; "Fantasies, Fables and Fabrications: Photoworks from the 1980's," Herder Art Gallery, University of Massachusetts at Amherst

1988 "Photokina '88," Cologne, West Germany; "Image and Text," Newton Art Center, Massachusetts

1986 "Survey of Upstate Photography," Visual Studies Workshop, Rochester, New York

1984 "Landscape/6," Connecticut College, New London; "The American Landscape," Hallmark traveling exhibition

1983 "Selections from the Hallmark Collection," Nelson Art Gallery, Kansas City, Missouri

1980 "Visual Studies Workshop: The First Ten Years," Pratt Graphic Center, Pratt Institute, Brooklyn, New York

1977 "Images of Women," Portland Museum of Art, Maine

DOUGLAS HUEBLER

Born 1924, Ann Arbor, Michigan

Resides Truro, Massachusetts

SELECTED SOLO EXHIBITIONS
1990 Richard Kuhlenschmidt Gallery, Los Angeles; Leo Castelli Gallery, New York City; Holly Solomon Gallery, New York City; Galerie Rudiger Schottle, Munich

1989 "Douglas Huebler: Crocodile Tears: Recent Additions," Musée St. Pierre, Art Contemporain, Lyon, France

1988 "Douglas Huebler," La Jolla Museum of Contemporary Art, California

1985 "Douglas Huebler: Crocodile Tears," Albright-Knox Art Gallery, Buffalo, New York

1984 "In Context," The Museum of Contemporary Art, Los Angeles; "Douglas Huebler 1968-1984," Los Angeles Center for Photographic Studies

1980 "Douglas Huebler: 10+," Dittmar Memorial Gallery, Northwestern University, Evanston, Illinois; Galerie Yvon Lambert, Paris

1979 "Everyone Alive 1979," MTL, Brussels; Rudiger Schottle, Munich; "Douglas Huebler: An Installation," Los Angeles County Museum of Art

1976 Sperone Westwater Fischer, New York City

1974 Konrad Fischer, Düsseldorf, West Germany

1973 Kunsthalle, Keil, West Germany; Israel Museum, Jerusalem; Museum of Modern Art, Oxford, England

1972 Museum of Fine Arts, Boston

1971 Leo Castelli Gallery, New York City; Art & Project, Amsterdam

1970 Addison Gallery of American Art, Andover, Massachusetts

1968 Seth Siegelaub, New York City

SELECTED GROUP EXHIBITIONS
1992 "Open Mind: The LeWitt Collection," Wadsworth Atheneum, Hartford, Connecticut

1989 "Words," Tony Shafrazi Gallery, New York City

1986 "The Real Big Picture," The Queens Museum, Flushing, New York

1985 "The Maximal Implications of the Minimal Line," Edith C. Blum Art Institute, Bard College, Annandale-on-Hudson, New York

1984 "Verbally Charged Images," Independent Curators Inc., New York City (traveling exhibition)

1983 "Comment," Long Beach Museum of Art, California; "Fragment/Fragmentary/Fragmentation," The New Britain Museum of American Art, Connecticut

1982 "Target III: In Sequence (Photographic series, sequences and sets from the Target Collection of American Photography)," The Museum of Fine Arts, Houston, Texas

1980 "Contemporary Art in Southern California," High Museum of Art, Atlanta, Georgia

1978 "Narration," The Institute of Contemporary Art, Boston

1976 "Drawing Now," The Museum of Modern Art, New York City; "The Artist and the Photograph," Israel Museum, Jerusalem

1974 "Idea and Image in Recent Art," The Art Institute of Chicago

1972 "Documenta 5," Museum Fridericianum, Kassel, West Germany

1971 "This is Not There," Everson Museum of Art, Syracuse, New York

1970 "The Highway," Institute of Contemporary Art, University of Pennsylvania, Philadelphia; "Information," The Museum of Modern Art, New York City

1969 "January Show," Seth Siegelaub, New York City; "Op Losse Schroven," Stedelijk Museum, Amsterdam; "557,087," Seattle Art Museum, Washington; "Artists and Photographs," Multiples Inc., New York City

1967 "Cool Art," The Aldrich Museum of Contemporary Art, Ridgefield, Connecticut

1957 "Biennial," The Corcoran Gallery of Art, Washington, D.C.

1953 "Concepts for Examining Concepts," Phillips Gallery, Detroit, Michigan

ALLAN KAPROW

Born 1927, Atlantic City, New Jersey

Resides Encinitas, California

SELECTED SOLO EXHIBITIONS
1992 "5 Environments, 1957 to 1964," Studio Morra, Naples, Italy

1991 "7 Environments, 1957-64," Fondazione Mudima, Milan, Italy

1979 Edwin A. Ulrich Museum of Art, The Wichita State University, Kansas

1978 Museum of the University of Northern Iowa, Cedar Falls

1976 "Activity Dokumente," Kunsthalle, Bremen, West Germany

1971 Galerie Baecker, Bochum, West Germany

1969 John Gibson Gallery, New York City

1955 Urban Gallery, New York City

SELECTED GROUP EXHIBITIONS
1991 "Pop Art: A Continuing History," Royal Academy of Arts, London; traveled to Museum Ludwig, Cologne, Germany and Centro de Arte Reina Sofía, Madrid; "Sixties," John Gibson Gallery, New York City

1990 "Biennale of Sydney," Australia; "Venice Biennale," Italy

1989 "The Junk Aesthetic," Whitney Museum of American Art at Equitable Center, New York City

1988 "Marcel Duchamp und die Avantgarde seit 1950," Museum Ludwig, Cologne, West Germany

1987 "Berlin 1961-87," The Museum of Modern Art, New York City

1984 "Blam! The Explosion of Pop, Minimalism, and Performance,

1958-64," Whitney Museum of American Art, New York City

1982 "Extended Uses of Photography," University of California, Los Angeles (3 Booklets of Activities)

1981 "California Performance: Then and Now," Museum of Contemporary Art, Chicago

1980 "Für Augen and Ohren," Akademie der Kunste, Berlin

1979 "The Animal Show," Los Angeles Contemporary Exhibitions (LACE); "Weich und Plastisch: Soft Art," Kunsthaus Zurich, Switzerland

1977 "1977 Biennial," Whitney Museum of American Art, New York City; "Paris-New York," Musée National d'Art Moderne, Centre Georges Pompidou, Paris

1976 "Annual Avantgarde Festival of New York," New York City

1975 "Americans in Florence: Europeans in Florence," Long Beach Museum of Art, California; "Video Art," Institute of Contemporary Art, University of Pennsylvania, Philadelphia

1974 Contemporanea, Rome; "Art/Video Confrontation 74," ARC, Musée d'Art Moderne de la ville de Paris

1972 "Art 3 '72," John Gibson Gallery, Kunstmarkt, Basel, Switzerland (3-person exhibition)

1970 "Happening und Fluxus," Neuer Kölnischer Kunstverein, Cologne, West Germany; "3 Toward Infinity: New Multiple Art," Whitechapel Art Gallery, London

1965 "Eleven from the Reuben Gallery," Solomon R. Guggenheim Museum, New York City

1963 "Push and Pull: A Furniture Comedy for Hans Hofmann," The Museum of Modern Art, New York City (traveling exhibition)

1960 "New Forms-New Media I," Martha Jackson Gallery, New York City

1958 "1958 Pittsburgh International Exhibition of

Contemporary Painting and Sculpture," Carnegie Institute, Pittsburgh, Pennsylvania

1957 "Collage In America," Zabriskie Gallery, New York City

SELECTED HAPPENINGS AND ACTIVITIES

1989 "Taking a Shoe for a Walk," Bonner Kunstverein, Bonn, West Germany (a salute to Fluxus)

1988 "Sweeping," University of Texas, Arlington

1987 "Basic Training," Zabriskie Gallery, New York City

1986 "The Conference as Performance," Richmond Museum of Art, Virginia

1984 "A Much Better Idea," Rancho Santa Fe, California

1982 "Company, 20th Year Anniversary Celebration," Rutgers University, New Brunswick, New Jersey

1980 "Long Exercise," Los Angeles Contemporary Exhibitions (LACE) and Public Spirit, Los Angeles

1977 "Timing" and "What's Cooking Festival 1," Center for Music Experiment, University of California, San Diego, La Jolla

1975 "Echo-logy," Merriewold West Gallery, Far Hills, New York

1973 "Routine," Portland Center for the Visual Arts, Oregon

1971 "Good Morning!," San Francisco State University

1968 "Dial," San Francisco Art Institute

1967 "Fluids," throughout Los Angeles area, commissioned by the Pasadena Art Museum, California

1962 "A Service for the Dead, I," Maidman Playhouse, New York City

1959 "18 Happenings in 6 Parts," Reuben Gallery, New York City

LOUISE LAWLER

Born 1947, Bronxville, New York

Resides New York City

SELECTED SOLO EXHIBITIONS

1991 "For Sale," Metro Pictures, New York City; Galerie Meert-Rihoux, Brussels

1990 "A Vendre," Galerie Yvon Lambert, Paris; "'The Enlargement of Attention, No One Between the Ages of 21 and 35 is Allowed,' Connections: Louise Lawler," Museum of Fine Arts, Boston

1989 "How Many Pictures," Metro Pictures, New York City; "The Show Isn't Over," Photographic Resource Center, Boston University, and Metro Pictures, New York City

1988 "Vous Avez Déjà Vu Ça," Galerie Yvon Lambert, Paris; Studio Guenzani, Milan, Italy (two-person exhibition with Cindy Sherman); Le Consortium, Dijon, France (two-person exhibition with Allan McCollum)

1987 "'Enough,' Projects: Louise Lawler," The Museum of Modern Art, New York City; "As Serious As A Circus," Isabella Kacprzak, Stuttgart, West Germany

1985 "Interesting," Nature Morte, New York City

1984 "Home/Museum - Arranged for Living and Viewing," Matrix Gallery, Wadsworth Atheneum, Hartford, Connecticut

1982 "An Arrangement of Pictures," Metro Pictures, New York City

1979 "A Movie Will Be Shown Without the Picture," Aero Theater, Santa Monica, California

1973 University of California, Davis

SELECTED GROUP EXHIBITIONS

1992 "Quotations: The Second History of Art," The Aldrich Museum of Contemporary Art, Ridgefield, Connecticut; "Knowledge: Aspects of Contemporary Art," University Art Museum, University of California, Santa Barbara, and North Carolina Museum of Art, Raleigh

1991 "1991 Biennial," Whitney Museum of American Art, New York City; "Devil on the Stairs: Looking Back on the Eighties," Institute of Contemporary Art, University of Pennsylvania, Philadelphia

1990 "The Decade Show: Frameworks of Identity in the 80's," The New Museum of Contemporary Art, New York City; "Word as Image: American Art 1960-1990," Milwaukee Art Museum, Wisconsin (traveling exhibition); "The Indomitable Spirit," organized by Photographers + Friends United Against AIDS, International Center of Photography Midtown, New York City

1989 "Art Collected: Private, Corporate and Museum Contexts," University Art Museum, State University of New York at Binghamton; "The Photography of Invention: American Pictures of the 1980s," National Museum of American Art, Smithsonian Institution, Washington, D.C. (traveling exhibition); "A Forest of Signs: Art in the Crisis of Representation," The Museum of Contemporary Art, Los Angeles; "Tenir l'image à distance," Musée d'Art Contemporain de Montréal

1988 "Investigations 1988," Institute of Contemporary Art, University of Pennsylvania, Philadelphia; "Five Installations," The Museum of Contemporary Art, Los Angeles; "Sexual Difference: Both Sides of the Camera," Wallach Art Gallery, Columbia University, New York City; "AIDS and Democracy," Dia Art Foundation, New York City

1987 "Art Against AIDS," Metro Pictures, New York City; "Photography and Art: Interactions Since 1946," Los Angeles County Museum of Art (traveling exhibition); "Implosion: A Postmodern Perspective," Moderna Museet, Stockholm, Sweden

1986 "The Real Big Picture," The Queens Museum, Flushing, New York; "Damaged Goods," The New Museum of Contemporary Art, New York City; "The Fairy Tale: Politics,

Desire and Everyday Life," Artists Space, New York City

1985 "Louise Lawler, Laurie Simmons, James Welling," Metro Pictures, New York City; "Production Re: Production," Gallery 345, New York City; "The Art of Memory, The Loss of History," The New Museum of Contemporary Art, New York City

1984 "Re-place-ment," Hallwalls, Buffalo, New York

1983 "Multiple Choice," P.S. 1, Long Island City, New York

1982 "A Picture is No Substitute for Anything," ID Gallery, California Institute of the Arts, Valencia; "Public Vision," White Columns, New York City

1981 "A PICTURE IS NO SUBSTITUTE FOR ANYTHING is the title of collaborative work of Louise Lawler and Sherrie Levine," Harold Rivkin, New York City; "Photo," Metro Pictures, New York City

1980 "Amalgum," Castelli Graphics, New York City

1978 "_____, Louise Lawler, Adrian Piper & Cindy Sherman Have Agreed to Participate in an Exhibition Organized by Janelle Reiring at Artists Space, September 23 through October 28, 1978," Artists Space, New York City

SOL LEWITT

Born 1928, Hartford, Connecticut

Resides Chester, Connecticut, New York City, and Spoleto, Italy

SELECTED SOLO EXHIBITIONS

1991 Lisson Gallery, London

1990 "Papiers dechires de 1975," Galerie de Poche, Paris; "Large Scale Concrete Block Sculpture," Max Protetch Warehouse, New York City

1989 "Sol LeWitt: Incomplete Open Cubes," Galerie Le Gall Peyroulet, Paris; "Installation and Sculpture," B.R. Kornblatt Gallery, Washington, D.C.

1988 "Wallworks," Williams College Museum of Art, Williamstown, Massachusetts; "Sol LeWitt Cube," John Weber Gallery, New York City

1987 "Wall Drawings," Galerie Yvon Lambert, Paris; Hirshhorn Museum and Sculpture Garden, Smithsonian Institution, Washington, D.C.

1986 "Inaugural Exhibition," The Drawing Center, New York City

1985 "Pyramid: A Wall Drawing by Sol LeWitt," The Brooklyn Museum, New York; "New Work: Sol LeWitt," Arthur M. Sackler Museum, Harvard University, Cambridge, Massachusetts

1984 "Wall Drawings and Works on Paper," Stedelijk Museum, Amsterdam; "Structures," Stedelijk Van Abbemuseum, Eindhoven, The Netherlands

1983 "Sol LeWitt: Star Prints," Matrix Gallery, University Art Museum, University of California, Berkeley

1982 "Drawings," David Bellman Gallery, Toronto; William Aronowitsch Gallery, Stockholm, Sweden

1981 "Photogrids, Brick Wall, Autobiography, On the Walls of the Lower East Side," University Art Gallery, New Mexico State University, Las Cruces

1980 "Photo Grids," Protetch-McIntosh, Washington, D.C.

1978-79 "Retrospective Exhibition," The Museum of Modern Art, New York City

1978 "Sol LeWitt: Drawings, Silkscreen Prints, Multiples Up to 1971," University Gallery, University of Massachusetts at Amherst

1976 "Wall Drawings," Matrix Gallery, Wadsworth Atheneum, Hartford, Connecticut

1974 "Prints," Stedelijk Museum, Amsterdam

1972 Hayden Gallery, Massachusetts Institute of Technology, Cambridge

1970 Art & Project, Amsterdam; Pasadena Art Museum, California

1969 Konrad Fischer Gallery, Düsseldorf, West Germany; Museum Haus Lange, Krefeld, West Germany

1965 Daniels Gallery, New York City

SELECTED GROUP EXHIBITIONS

1991 "Motion and Document-Sequence and Time: Eadweard Muybridge and Contemporary American Photography," Addison Gallery of American Art, Andover, Massachusetts (traveling exhibition)

1990-91 "Works for New Spaces: Into the Nineties," Wexner Center for the Arts, The Ohio State University, Columbus

1990 "The Humanist Icon," Bayly Art Museum of The University of Virginia, Charlottesville, The New York Academy of Art, New York City, and Edwin A. Ulrich Museum of Art, The Wichita State University, Kansas; "Project Room," John Weber Gallery, New York City

1989 "Art Conceptual," ARC, Musée d'Art Moderne de la Ville de Paris (traveling exhibition); "Minimalism," The Tate Gallery, Liverpool, England; "Photographs by Painters and Sculptors: Another Focus," Karsten Schubert Ltd., London

1988 "Venice Biennale," Italy; "Minimal & Conceptual," Galerie Gabrielle Maubrie, Paris

1987 "1987 Biennial," Whitney Museum of American Art, New York City; "From the Collection of Sol LeWitt," Wadsworth Atheneum, Hartford, Connecticut

1986 "Forty Years of Modern Art 1945-1985," Tate Gallery, London; "The Law and Order Show," Leo Castelli, Barbara Gladstone, and John Weber Galleries, New York City

1985 "Minimal Art: A Survey of Early & Recent Work: Andre, Judd, LeWitt, Martin, Mangold, Marden, Morris, Ryman, Smithson," John Weber Gallery, New York City; "Process und Konstruktion," Kunstlerwerkstatten, Munich

1984 "American Art Since 1970: Painting, Sculpture, and Drawings from the Collection of the Whitney Museum of American Art," Whitney Museum of American Art, New York City (traveling exhibition); "Artists Call Against U.S. Intervention in Central America," Paula Cooper Gallery, New York City; "Legendes," CAPC, Musée d'Art Contemporain, Bordeaux, France

1983 "Artists Use of Language, Part II," Franklin Furnace, New York City; "Big Pictures by Contemporary Photographers," The Museum of Modern Art, New York City

1982 "A Century of Modern Drawing," The Museum of Modern Art, New York City; "Objekt, Skulptur, Installation," Halle 6, Kampnagel-Fabrik, Hamburg, West Germany

1981 "Artists, Gardens and Parks-Plans, Drawings, & Photographs," Hayden Gallery, Massachusetts Institute of Technology, Cambridge, and Museum of Contemporary Art, Chicago

1980 "Printed Matter," The Museum of Modern Art, New York City; "Perceiving Modern Sculpture, Selections for the Sighted & Non-Sited," The Grey Art Gallery and Study Center, New York University, New York City

1977 "Documenta 6," Museum Fridericianum, Kassel, West Germany

1975 "34th Biennial of Contemporary American Painting," The Corcoran Gallery of Art, Washington, D.C.

1972 "Grids," Institute of Contemporary Art, University of Pennsylvania, Philadelphia

1970 "Artists & Photographs," Multiples Inc., New York City

1968-69 "The Art of the Real," The Museum of Modern Art, New York City

1968 "Cool Art," The Aldrich Museum of Contemporary Art, Ridgefield, Connecticut; "Documenta 4," Museum Fridericianum, Kassel, West Germany

1966 "Multiplicity," The Institute of Contemporary Art, Boston

1965 "Box Show," Byron Gallery, New York City

1963 St. Mark's Church, New York City

ARNAUD MAGGS

Born 1926, Montreal

Resides Toronto

SELECTED SOLO EXHIBITIONS

1992 "Hotel," Art Metropole and Cold City Gallery, Toronto; Presentation House Gallery, Vancouver, British Columbia, Canada

1991 "Köchel Series," Cold City Gallery, Toronto

1990 "Identification," Centre Saidye Bronfman, Montreal; "Joseph Beuys," Neuberger Museum, State University of New York at Purchase; "8 Numberworks," Southern Alberta Art Gallery, Lethbridge, Canada

1989 "Joseph Beuys," Stux Gallery, New York City; "Numberworks," Macdonald Stewart Art Centre, Guelph, Canada

1988 "The Complete Prestige 12" Jazz Catalogue," YYZ, Toronto

1986 "Photographs 1975-84," Art Gallery of Hamilton and Winnipeg Art Gallery, Canada

1985 "Düsseldorf Photographs," The Isaacs Gallery, Toronto

1984 "Photographs 1975-84," Charles H. Scott Gallery, British Columbia, Vancouver and Nickle Arts Museum, Calgary, Canada

1983 "Joseph Beuys," Optica, Montreal; "Turning," The Photography Gallery, Harbourfront, Toronto

1982 "48 Views Series," Jane Corkin Gallery, Toronto

1981 "Downwind Photographs," Mercer Union, A Center for Contemporary Art, Toronto

1980 Centre Culturel Canadien, Paris

1979 "Ledoyen Series," YYZ, Toronto

1978 Anna Leonowens Gallery, Halifax, Canada; "64 Portrait Studies," David Mirvish Gallery, Toronto

SELECTED GROUP EXHIBITIONS
1992 "Beau," Canadian Museum of Contemporary Photography, Ottawa and Centre Culturel Canadien, Paris

1991 "Photo Based Works," 49th Parallel, New York City; "New Aquisitions," National Gallery of Canada, Ottawa

1990 "Works from the Collection," National Gallery of Canada, Ottawa; "Numbering," Art Gallery of Hamilton, Canada; "Invitational," Cold City Gallery, Toronto

1985 "Identités," Centre National de la Photographie, Paris; "Contemporary Canadian Photography," National Gallery of Canada, Ottawa

1984 "Responding to Photography," Art Gallery of Ontario, Toronto; "Evidence of the Avant-Garde since 1957," Art Metropole, Toronto; "Allocations," 49th Parallel, New York City; "Seeing People, Seeing Space," Photographers' Gallery, London

1982 "Persona," Nickle Arts Museum, Calgary, Canada

1981 "Realism: Structure and Illusion," Macdonald Stewart Art Centre, Guelph, Canada

1979 "Photo-Extended Dimensions," Art Gallery of Winnipeg, Canada

1977 "7 Canadian Photographers," National Film Board, Canada

ANNETTE MESSAGER

Born 1943, Berck-sur-Mer, France

Resides Malakoff, France

SELECTED SOLO EXHIBITIONS
1992 The University of Iowa Museum of Art, Iowa City

1991 "Annette Messager: making up stories/faire des histoires," Mercer Union, A Center for Contemporary Visual Art and Cold City Gallery, Toronto; Contemporary Art Gallery, Vancouver, British Columbia, Canada

1990 "Annette Messager: Cracher le morceau," Musée de la Roche sur Yon, France; "Faire des histoires," Kunstverein für die Rheinlande und Westfalen, Düsseldorf, Germany; Galerie Crousel-Robelin Bama, Paris

1989 "Annette Messager: comédie tragédie, 1971-1989," Musée de Grenoble, France; "Mes Enluminures," Galerie Crousel-Robelin Bama, Paris; Eglise Saint-Martin du Méjan, Arles, France

1987 Vancouver Art Gallery, British Columbia, Canada; Art Space, Sydney, Australia; "La ruée vers l'art," Ministère de la Culture et de la Communication, Paris

1985 Riverside Studios, London; Galerie Gillespie-Laage-Salomon, Paris

1983 Galerie Gillespie-Laage-Salomon, Paris; Musée des Beaux-Arts, Calais, France

1981 Fine Arts Gallery, University of California, Berkeley; P.S. 1, Long Island City, New York; Artists Space, New York City

1979 Galerie Gillespie-Laage, Paris

1978 Holly Solomon Gallery, New York City

1977 Galerie Seriaal, Amsterdam

1976 Gallerie Multimedia, Ebrusce, Italy

1975 Galerij Suvremene Umjetnost, Zagreb, Yugoslavia

1974 ARC, Musée d'Art Moderne de la Ville de Paris

1973 Musée de Peinture et de Sculpture, Grenoble, France

SELECTED GROUP EXHIBITIONS
1992 "Parallel Visions: Modern Artists and Outsider Art," Los Angeles County Museum of Art (traveling exhibition)

1991 "Individualités: 14 Artists from France," Art Gallery of Ontario, Toronto; "Sweet Dreams," Barbara Toll Fine Arts, New York City

1990 "Biennale of Sydney," Australia; "Sarah Charlesworth, Jeanne Dunning, Annette Messager, Adrian Piper, Laurie Simmons," Feigen Inc., Chicago; "Stendhal Syndrome: The Cure," Andrea Rosen Gallery, New York City; "La choix des femmes," Le Consortium, Dijon, France

1989 "Images of Women and Ideas of Nation," Walker Art Gallery, Liverpool, England; "L'invention d'un art," Musée National d'Art Moderne, Centre Georges Pompidou, Paris

1987 "Exotische Welten Europäische Phantasien," Württembergischer Kunstverein, Stuttgart, West Germany; "Des animaux et des hommes," Musée d'Ethnographie, Neuchâtel Chapelle de la Salpétrière, Paris

1985 "Dialog," Moderna Museet, Stockholm, Sweden; "Livres d'Artistes," Musée National d'Art Moderne, Centre Georges Pompidou, Paris

1983 "Kunst mit Fotografie," Nationalgalerie, Berlin; "New Art 83," Tate Gallery, London

1981 "Art & Culture," Kunstverein, Stuttgart, West Germany; "Autoportraits photographiques 1898-1981," Musée National d'Art Moderne, Centre Georges Pompidou, Paris

1980 "Ils se disent peintres, ils se disent photographes," ARC, Musée d'Art Moderne de la Ville de Paris

1978 "Couples," P.S. 1, Long Island City, New York

1977 "Documenta 6," Museum Fridericianum, Kassel, West Germany

1976 "Identité/Identification," CAPC, Musée d'Art Contemporain, Bordeaux, France

1974 "Ils collectionnent," Musée des Arts Décoratifs, Paris

RAY METZKER

Born 1931, Milwaukee, Wisconsin

Resides Philadelphia, Pennsylvania

SELECTED SOLO EXHIBITIONS
1992 "Composites," Laurence Miller Gallery, New York City

1990 Laurence Miller Gallery, New York City

1988 Kathleen Ewing Gallery, Washington, D.C.

1987 G.H. Dalsheimer Gallery, Baltimore, Maryland

1986 High Museum of Art, Atlanta, Georgia; National Museum of American Art, Smithsonian Institution, Washington, D.C.

1985 Davison Art Center, Wesleyan University, Middletown, Connecticut; San Francisco Museum of Modern Art; The Art Institute of Chicago; Philadelphia Museum of Art, Pennsylvania

1984 Laurence Miller Gallery, New York City; The Museum of Fine Arts, Houston, Texas

1983 Edwynn Houk Gallery, Chicago; G.H. Dalsheimer Gallery, Baltimore, Maryland; Carl Solway Gallery, Cincinnati, Ohio

1981 Paul Cava Gallery, Philadelphia, Pennsylvania; Light Gallery, New York City

1980 Light Gallery, New York City

1978 International Center of Photography, New York City

1974 Print Club of Philadelphia, Pennsylvania

1967 The Museum of Modern Art, New York City

1959 The Art Institute of Chicago

SELECTED GROUP EXHIBITIONS
1991 "Motion and Document-Sequence and Time: Eadweard Muybridge and Contemporary American Photography," Addison Gallery of American Art, Andover, Massachusetts (traveling exhibition)

1990 "Photography Until Now," The Museum of Modern Art, New York City

1989 "Invention and Continuity in Contemporary Photography," The Metropolitan Museum of Art, New York City; "On the Art of Fixing a Shadow: One Hundred and Fifty Years of Photography," National Gallery of Art, Washington, D.C., and The Art Institute of Chicago

1987 "American Dreams," Ministry of Culture, Barcelona; "Photography and Art: Interactions Since 1946," Los Angeles County Museum of Art, (traveling exhibition)

1985 "American Images," Barbican Art Gallery, London

1983 "Big Pictures by Contemporary Photographers," The Museum of Modern Art, New York City

1982 San Francisco Museum of Modern Art; The Art Institute of Chicago; Philadelphia Museum of Art, Pennsylvania

1981 "Erweiterte Fotografie/Extended Photography," Vienna Secession, Austria

1980 "Deconstruction/ Reconstruction: The Transformation of Photographic Information into Metaphor," The New Museum of Contemporary Art, New York City

1978 "Mirrors and Windows: American Photography Since 1960," The Museum of Modern Art, New York City

1973 "Landscape/Cityscape: A Selection of Twentieth-Century American Photographs," The Metropolitan Museum of Art, New York City

1968 "Photography as Printmaking," The Museum of Modern Art, New York City

1967 "The Persistence of Vision," International Museum of Photography at George Eastman House, Rochester, New York

1962 "Photography, U.S.A.," De Cordova Museum and Sculpture Park, Lincoln, Massachusetts

1959 "Photography in the Fine Arts I," The Metropolitan Museum of Art, New York City

GARRY FABIAN MILLER

Born 1957, Bristol, England

Resides Newton Abbot, Devon, England

SELECTED SOLO EXHIBITIONS
1991 "The Gatherer," John Hansard Gallery, Southampton, Newlyn Orion, Cornwall, Mead Gallery, University of Warwick, and The Cambridge Darkroom, England

1990 "Of Nature," Newlyn Orion, England

1988 "A Gathering in for the Healing," The Natural History Museum, London

1987 "The Tree, A Return to Grace," The Usher Gallery, Lincoln, and Gainsborough's House, Sudbury, Suffolk, England

1986 "Man from Hunter to Gatherer," Axiom, Cheltenham, Impressions, York, and Watershed, Bristol, England

1985 Untitled Gallery, Sheffield, England

1984 "Green Grain," The Festival Gallery, Bath, England

1983 "Ritual of Gathered Grain," The Usher Gallery, Lincoln, England

1979 Arnofini, Bristol, England

SELECTED GROUP EXHIBITIONS
1990 "The Journey," Lincoln Cathedral, England; "Collecting for the Future: A Decade of Contemporary Acquisitions," Victoria and Albert Museum, London

1989-90 "New Icons," Mead Gallery, Warwick, England; "Anima Mundi," Canadian Museum of Contemporary Photography, Ottawa

1989 "Photo Sculpture," Watershed, Bristol, England; "The Bristol Sculpture Project," Bristol, England; "Out of the Wood," Crafts Council of Great Britain (traveling exhibition); "The Tree of Life," South Bank

Centre, England (traveling exhibition); "Towards a Bigger Picture," The Tate Gallery, Liverpool, England

1988-89 "Artists in National Parks," Victoria and Albert Museum, London

1987 "Toward a Bigger Picture," Victoria and Albert Museum, London

1986-87 "Image and Exploration," Photographers' Gallery, London; "The Elements," Milton Keynes Exhibition Gallery, Milton Keynes, England

RICHARD PRINCE

Born 1949, Panama Canal Zone

Resides New York City

SELECTED SOLO EXHIBITIONS
1992 "Richard Prince," Whitney Museum of American Art, New York City

1991 Barbara Gladstone Gallery, New York City; Galerie Ghislaine Hussenot, Paris

1990 "Richard Prince: Jokes, Gangs, Hoods," Galerie Rafael Jablonka and Galerie Gisela Capitain, Cologne, Germany; "Richard Prince," Galerij Micheline Szwajcer, Antwerp, Belgium

1989 "Spiritual America," IVAM Centre del Carme, Valencia, Spain; "Richard Prince-Sculpture," Barbara Gladstone Gallery and "Richard Prince-Paintings," Jay Gorney Modern Art, New York City (joint exhibitions); Daniel Weinberg Gallery, Los Angeles

1988 Centre National D'Art Contemporain de Grenoble, France; Barbara Gladstone Gallery, New York City; Le Case d'Arte, Milan, Italy; Galerie Rafael Jablonka, Cologne, West Germany

1987 Gutenbergstrasse 62a e.V., Stuttgart, West Germany; Daniel Weinberg Gallery, Los Angeles

1986 International with Monument, New York City; Feature Gallery, Chicago

1985 International with Monument, New York City; Richard Kuhlenschmidt Gallery, Los Angeles

1984 Riverside Studios, London; Feature Gallery, Chicago; Baskerville + Watson, New York City

1983 Le Nouveau Musée, Lyon, France; Institute of Contemporary Arts, London

1982 Metro Pictures, New York City

1981 Metro Pictures, New York City; Richard Kuhlenschmidt Gallery, Los Angeles

1980 Artists Space, New York City; CEPA Gallery, Buffalo, New York

SELECTED GROUP EXHIBITIONS
1991 "Power: Its Myths, Icons, and Structures in American Art, 1961-1991," Indianapolis Museum of Art, Indiana; "20th Century Collage," Margo Leavin Gallery, Los Angeles; "Words & #'s," Museum of Contemporary Art at Wright State University, Dayton, Ohio

1990 "Images in Transition: Photographic Representation in the Eighties," National Museum of Modern Art, Kyoto, and National Museum of Modern Art, Tokyo, Japan; "The Indomitable Spirit," organized by Photographers + Friends United Against AIDS, International Center of Photography Midtown, New York City

1989 "Image World: Art and Media Culture," Whitney Museum of American Art, New York City; "A Forest of Signs: Art in the Crisis of Representation," The Museum of Contemporary Art, Los Angeles; "Photography Now," Victoria and Albert Museum, London

1988 "BiNATIONALE: Deutsche/ Amerikanische Kunst der 80er Jahre," Kunstverein fur die Rheinlande und Westfalen, Düsseldorf, West Germany (traveling exhibition); "Nostalgia as Resistance," The Clocktower Gallery, New York City; "Venice Biennale," Italy

1987 "Photography and Art: Interactions Since 1946," Los Angeles County Museum of Art (traveling exhibition); "1987 Biennial," Whitney Museum of American Art, New York City

1986 "Biennale of Sydney," Australia; "As Found," The Institute of Contemporary Art, Boston; "Products and Promotion," San Francisco Camerawork Gallery; "The Real Big Picture," The Queens Museum, Flushing, New York

1985 "1985 Biennial," Whitney Museum of American Art, New York City; "Strategies of Appropriation," Center for Contemporary Arts, Santa Fe, New Mexico

1984 "Pop," Spiritual America, New York City; "The Heroic Figure," Contemporary Arts Museum, Houston, Texas; "Drawings: After Photography," Allen Memorial Art Museum, Oberlin College, Ohio

1983 "Language, Drama, Source and Vision," The New Museum of Contemporary Art, New York City

1982 "Image Scavengers," Institute of Contemporary Art, University of Pennsylvania, Philadelphia

1981 "New Voices 2: Six Photographers Concept/Theater/ Fiction," Allen Memorial Art Museum, Oberlin College, Ohio; "5th Wiener Internationale Biennale," Vienna Secession, Austria

1980 "Ils se disent peintres, ils se disent photographes," ARC, Musée d'Art Moderne de la Ville de Paris; "Opening Group Exhibitions," Metro Pictures, New York City

1979 "Imitation of Life," Hartford Art School, University of Hartford, Connecticut

ALAN RATH

Born 1959, Cincinnati, Ohio

Resides Oakland, California

SELECTED SOLO EXHIBITIONS
1991 Walker Art Center, Minneapolis, Minnesota; Carl Solway Gallery, Cincinnati, Ohio

1990 Dorothy Goldeen Gallery, Santa Monica, California; San Jose Museum of Art, California

1989 "Past/Recent Sculpture: Information Systems," Katia Lacoste Gallery, San Jose, California

1988 "Systems for Neo-Pagans," New Langton Arts, San Francisco

1987 "Don't Call It Video, Call It Sculpture," Pro Arts, Oakland, California; "Video Sculpture," Memorial Union Art Gallery, University of California, Davis

1986 "Video Sculpture," Artists' Television Access Gallery, San Francisco; "Electronic Scupture," WORKS/San Jose, California

1984 "Interactive Environment," Center for Advanced Visual Studies, Massachusetts Institute of Technology, Cambridge

SELECTED GROUP EXHIBITIONS
1991 "1991 Biennial," Whitney Museum of American Art, New York City; "Mechanika," The Contemporary Arts Center, Cincinnati, Ohio; "Visions/Revisions," Denver Art Museum, Colorado

1990 "Bay Area Media," San Francisco Museum of Modern Art; "Images du Futur 90," Cite des Arts et des Nouvelles Technologies, Montreal; "P.U.L.S.E. 2," University Art Museum, University of California, Santa Barbara

1989 "Matter, Anti-matter: Defects in the Model," Terrain Gallery, San Francisco; "Sculpture," Carl Solway Gallery, Cincinnati, Ohio; "Ars Electronica," Brucknerhaus, Linz, Austria; "Singular Spaces/ Phenomenal Places," The Contemporary Arts Center, Cincinnati, Ohio

1988 "Interactive Techniques," Siggraph '88, Atlanta, Georgia; "Digital Photography," San Francisco Camerawork Gallery (traveling exhibition)

1987 "High Tech, New Pop," Photographic Resource Center, Boston University; "Computers and Art," Everson Museum of Art, Syracuse, New York (traveling exhibition)

1986 "Four on the Floor," San Francisco International Video Festival; "Art and the Computer," Berkeley Art Center, California

1985 "Environmental Light Sculpture," Sausalito Arts Festival, California

1984 "Light Wall," Boston "First Night" Celebration of the Arts

EDWARD RUSCHA

Born 1937, Omaha, Nebraska

Resides Venice, California

SELECTED SOLO EXHIBITIONS
1992 "Ed Ruscha: Stains 1971-1975," Robert Miller Gallery, New York City

1991 "Edward Ruscha Recent Editions," Castelli Graphics, New York City; Leo Castelli Gallery, New York City

1990 "Ed Ruscha: Gasoline Stations 1962," Robert Miller Gallery, New York City; "Edward Ruscha," Trisorio, Naples, Italy; "Ed Ruscha," Centre Cultural de la Fundacio Caixa de Pension, Barcelona; "Ed Ruscha," Galerie Ghislaine Hussenot, Paris; "Edward Ruscha," The Museum of Contemporary Art, Los Angeles

1989-90 "Ed Ruscha," Musée National d'Art Moderne, Centre Georges Pompidou, Paris

1989 "Edward Ruscha: Selected Works of the 80's," James Corcoran Gallery, Los Angeles; "Ed Ruscha: New Paintings and Works on Paper," Rhona Hoffman Gallery, Chicago

1987 "Edward Ruscha Drawings: 1968-1972," Acme Art, San Francisco; "Ed Ruscha: New Paintings," Robert Miller Gallery, New York City

1985 "Ed Ruscha," Musée St. Pierre, Lyon, France; "Ed Ruscha," Galerie Tanja Grunert, Cologne, West Germany

1983 "Edward Ruscha," Route 66, Philadelphia, Pennsylvania; "Ed Ruscha: New Works," Bernard Jacobson Ltd., Los Angeles

1982 "The Works of Edward Ruscha," San Francisco Museum of Modern Art, Whitney Museum of American Art, New York City, and Los Angeles County Museum of Art

1981 "Ed Ruscha New Works," Arco Center for Visual Art, Los Angeles; "D Drawings," Leo Castelli Gallery, New York City

1978 "Drawings and Prints," Castelli Graphics, New York City; "Books," Rudiger Schottle, Munich

1976 Institute of Contemporary Arts, London; "Ed Ruscha/Matrix 16," Wadsworth Atheneum, Hartford, Connecticut

1973 Leo Castelli Gallery, New York City

1971 The Minneapolis Institute of Arts, Minnesota

1970 Alexander Lolas Gallery, New York City

1968 Irving Blum Gallery, New York City

1963 Ferus Gallery, Los Angeles

SELECTED GROUP EXHIBITIONS
1992 "A Passion for Art – Watercolors and Works on Paper," Tony Shafrazi Gallery, New York City

1991-92 "The Painted Word," Beth Urdang Fine Art, Boston; "Large Scale: Drawings and Prints," Leo Castelli Gallery, New York City

1990 "Silhouettes: Prints and Multiples," University Gallery, University of Massachusetts at Amherst; "LA Pop in the Sixties," Southand Theater Galleries, Neuberger Museum, State University of New York at Purchase

1988 "As Far as the Eye Can See," Marian Goodman Gallery, New York City; "Altered States," Kent Fine Art, New York City; "Visions/Revisions: Contemporary Representation," Marlborough Gallery, New York City

1986 "Text and Image: The Wording of American Art," Holly Solomon Gallery, New York City; "In Other Words...," The Corcoran Gallery of Art, Washington, D.C.; "What It Is,"

Tony Shafrazi, New York City; "Real Surreal," Lorence Monk Gallery, New York City; "The Real Big Picture," The Queens Museum, Flushing, New York

1984 "The Innovative Landscape," Holly Solomon Gallery, New York City; "Masters of the Sixties: From New Realism to Pop Art," Marisa del Re Gallery, New York City

1982 "Painting," Metro Pictures, New York City; "Documenta 7," Museum Fridericianum, Kassel, West Germany; "Target III in Sequence (Photographic series, sequences and sets from the Target Collection of American Photography)," The Museum of Fine Arts, Houston, Texas

1980 "Printed Art: A View of Two Decades," The Museum of Modern Art, New York City; "Contemporary Art in Southern California," High Museum of Art, Atlanta, Georgia

1978 "Selections from the Frederick Weisman Company Collection of California Art," University Art Museum, California State University, Long Beach

1976 "Venice Biennale," Italy; "The Artist and the Photograph," Israel Museum, Jerusalem

1974 "Pop Art," Whitney Museum of American Art, New York City

1971 "Continuing Surrealism," La Jolla Museum of Contemporary Art, California

1970 "Venice Biennale," Italy

1969 "Pop Art," Hayward Gallery, London; "Superlimited: Books, Boxed and Things," The Jewish Museum, New York City

1967 "Annual Exhibition, Painting," Whitney Museum of American Art, New York City

1964 "American Drawings," Solomon R. Guggenheim Museum, New York City

1962 "New Paintings of Common Objects," Pasedena Art Museum, California

MITCHELL SYROP

Born 1953, Yonkers, New York

Resides Los Angeles

SELECTED SOLO EXHIBITIONS

1992 Rosamund Felsen Gallery, Los Angeles

1990 Galeria Oliva Arauna, Madrid; Lieberman & Saul Gallery, New York City

1989 Lieberman & Saul Gallery, New York City; University Art Museum, University of California, Santa Barbara

1988 Kuhlenschmidt-Simon, Los Angeles

1987 Matrix Gallery, University Art Museum, University of California, Santa Barbara

1986 Kuhlenschmidt-Simon, Los Angeles

1985 Westbeach Cafe, Venice, California

1984 Richard Kuhlenschmidt Gallery, Los Angeles

SELECTED GROUP EXHIBITIONS

1991 "Body/Language," Lannan Foundation, Los Angeles; "Recent Work/Recent Acquisitions," The Museum of Contemporary Art, Los Angeles; "Different Stories: Five Views of the Collection," Newport Harbor Art Museum, Newport Beach, California; "Selections From the Permanent Collection," The Museum of Contemporary Art, Los Angeles

1990 "Hacia el Paisaje," (Toward Landscape), Centro Atlantico de Arte Moderno, Las Palmas, Spain; "Word As Image: American Art, 1960-1990," Milwaukee Art Museum, Wisconsin (traveling exhibition); "L.A.: My Third Lady," Tanja Grunert Gallery, Cologne, Germany; "Constructing a History: A Focus on MOCA's Permanent Collection," The Museum of Contemporary Art, Los Angeles; "Crossing The Line: Word and Image in Art, 1960-1990," Montgomery Gallery, Pomona College, Claremont, California

1989 "The Photography of Invention: American Pictures of the 1980s," National Museum of American Art, Smithsonian Institution, Washington, D.C. (traveling exhibition); "A Forest of Signs: Art in the Crisis of Representation," The Museum of Contemporary Art, Los Angeles; "AIDS Timeline," organized by Group Material, University Art Museum, University of California, Berkeley, and Wadsworth Atheneum, Hartford, Connecticut

1988 "Town Meeting," organized by Group Material, Dia Art Foundation, New York City; "Striking Distance," The Museum of Contemporary Art, Los Angeles

1987 "Avant-Garde in the Eighties," Los Angeles County Museum of Art; "CalArts: Skeptical Belief(s)," Renaissance Society, University of Chicago; "L.A. Hot & Cool," List Visual Art Center, Massachusetts Institute of Technology, Cambridge; "Visual Paradox: Truth and Fiction in the Photographic Image," John Michael Kohler Arts Center, Sheboygan, Wisconsin

1986 "Products and Promotion," San Francisco Camerawork Gallery and Franklin Furnace, New York City; "TV Generations," Los Angeles Contemporary Exhibitions (LACE), Los Angeles

1985 "Word/Image," New Langton Arts, San Francisco; "Public Art," Nexus Contemporary Arts Center, Atlanta, Georgia; "Blow Up," Feature, Chicago

1984 "Video: A Retrospective/Long Beach Museum of Art, 1974-1984," Long Beach Museum of Art, California

1983 "Los Angeles/New York Exchange," Artists Space, New York City; "Headhunters," Los Angeles Contemporary Exhibitions (LACE), Los Angeles

1980 "30/60 TV Art," Long Beach Museum of Art, California

1979 "Eleven Artists," Nexus Gallery, Los Angeles; "Watch It. Think It." KCOP-TV, Channel 13, Los Angeles (Film broadcast as a commercial during the 11:00 pm news, 2 consecutive nights. Sponsored by the Long Beach Museum of Art.)

ANDY WARHOL

Born 1928, Pittsburgh, Pennsylvania

Died 1987, New York City

SELECTED SOLO EXHIBITIONS

1992 "Andy Warhol: Polaroids 1971-1986," Pace/MacGill Gallery, New York City

1989 "Andy Warhol: A Retrospective," The Museum of Modern Art, New York City

1988-89 "Andy Warhol Death and Disaster," The Menil Collection, Houston

1988 "Andy Warhol: Silkscreens of the '80s," Dorsky Gallery, New York City; "Andy Warhol: Prints," Galerie Bernd Klüser, Munich

1987 "Andy Warhol: A Memorial," Dia Art Foundation, New York City; "Andy Warhol: Recent Work," Leo Castelli Gallery, New York City; "Andy Warhol Photographs," Robert Miller Gallery, New York City

1986 "Andy Warhol: Major Prints," Galerie Daniel Templon, Paris; "Andy Warhol Disaster Paintings 1963," Dia Art Foundation, New York City

1985 "The Silkscreens of Andy Warhol: 1962-1985," Lehman College Art Gallery, Lehman College (CUNY), Bronx, New York

1983 "Warhol's Animals: Species at Risk," American Museum of Natural History, New York City; "Andy Warhol in the 1980's," The Aldrich Museum of Contemporary Art, Ridgefield, Connecticut

1982 "Andy Warhol: Dollar Signs," Galerie Daniel Templon, Paris; "Andy Warhol: Portrait Screenprints 1965-1980," Dover Museum, England (traveling exhibition)

1980 "Andy Warhol: Exposures," Stedelijk Museum, Amsterdam; "Portraits of Jews of the Twentieth Century," The Jewish Museum, New York City

1979 "Andy Warhol," Wadsworth Atheneum, Hartford, Connecticut; "Andy Warhol, Multiple Images: Landscapes, City Spaces, Country Places," Arts Gallery, Baltimore, Maryland; "Andy Warhol: Portraits of the 70s," Whitney Museum of American Art, New York City

1977 "Retrospective Exhibition of Paintings by Andy Warhol from 1962-1976," Pyramid Galleries, Washington, D.C.

1975 "Andy Warhol: Paintings 1962-1975," Baltimore Museum of Art, Maryland; "Andy Warhol," Max Protetch Gallery, Washington, D.C.

1973 John Berggruen Gallery, San Francisco; Irving Blum Gallery, Los Angeles

1971 "Andy Warhol," Cenobio-Visualita, Milan, Italy; "Andy Warhol: His Early Works, 1947-1959," Gotham Book Mart Gallery, New York City; "Andy Warhol Graphik, 1964 bis 1970," Museum Haus Lange, Krefeld, West Germany

1970 "Andy Warhol," Pasadena Art Museum, California; travels to Museum of Contemporary Art, Chicago; Stedelijk Van Abbe Museum, Eindhoven, The Netherlands; Musée d'Art Moderne de la Ville de Paris; Tate Gallery, London; and Whitney Museum of American Art, New York City

1969 "Andy Warhol," Nationalgalerie and Deutsche Gesellschaft für Bildende Kunst, Berlin; "Andy Warhol," Castelli/ Whitney Graphics, New York City

1967 "Andy Warhol Most Wanted," Galerie Rudolf Zwirner, Cologne, West Germany; "The Thirteen Most Wanted Men," Galerie Ileana Sonnabend, Paris; Kunstkabinett Hans Neuendorf, Hamburg, West Germany

1966 "Warhol," Gian Enzo Sperone, Turin, Italy; "Andy Warhol," Leo Castelli Gallery, New York City; "Andy Warhol," The Institute of Contemporary Art, Boston

1965 "Andy Warhol," Galeria Rubbers, Buenos Aires, Argentina; "Andy Warhol," Institute of Contemporary Art, University of Pennsylvania, Philadelphia

1964 "Warhol," Galerie Ileana Sonnabend, Paris; "Warhol," Stable Gallery, New York City; "Andy Warhol," Leo Castelli Gallery, New York City

1963 "Andy Warhol," Ferus Gallery, New York City

1962 "Campbell's Soup Cans," Ferus Gallery, New York City; "Andy Warhol," Stable Gallery, New York City

1957 "A Show of Golden Pictures by Andy Warhol," Bodley Gallery, New York City

1956 "The Golden Slipper Show or Shoes Shoe in America," Bodley Gallery, New York City

1954 "Warhol," Loft Gallery, New York City

1952 "Andy Warhol: Fifteen Drawings Based on the Writings of Truman Capote," Hugo Gallery, New York City

SELECTED GROUP EXHIBITIONS
1986 "The Real Big Picture," The Queens Museum, Flushing, New York

1985 "Repetitions: A Post-Modern Dynamic," Hunter College Art Gallery, New York City

1983 "Trends in Postwar American and European Art," Solomon R. Guggenheim Museum, New York City

1982 "Documenta 7," Museum Fridericianum, Kassel, West Germany

1981 "Westkunst," Museen der Stadt Köln, Cologne, West Germany

1980 "Hidden Desires," Neuberger Museum, State University of New York at Purchase

1978 "Art About Art," Whitney Museum of American Art, New York City

1974 "Pop Art," Whitney Museum of American Art, New York City

1972 "Grids," Institute of Contemporary Art, University of Pennsylvania, Philadelphia

1970 "Expo '70," Osaka, Japan, United States Pavilion

1969 "New York Painting and Sculpture: 1940-70," The Metropolitan Museum of Art, New York City; "1969 Biennial," Whitney Museum of American Art, New York City

1968 "Documenta 4," Museum Fridericianum, Kassel, West Germany

1967 "Expo '67," Montreal, United States Pavilion

1966 "The Photographic Image," Solomon R. Guggenheim Museum, New York City; "Multiplicity," The Institute of Contemporary Art, Boston

1963 "Six Painters and the Object," Solomon R. Guggenheim Museum, New York City; "Pop Art USA," Oakland Museum of Art, California; "The Popular Image," Institute of Contemporary Arts, London

1962 "The New Realists," Sidney Janis Gallery, New York

ROBERT WATTS

Born 1923, Burlington, Iowa

Died 1988, Easton, Pennsylvania

SELECTED SOLO EXHIBITIONS
1991 "Watts Natural," Lafayette College, Easton, Pennsylvania

1990 "A Tribute to Robert Watts," Leo Castelli Gallery, New York City; "Robert Watts: Selected Works, 1960-1988," Carl Solway Gallery, Cincinnati, Ohio; "Robert Watts, L'Objet Photographique et Autres Oeuvres," Galerie Zabriskie, Paris

1989 "Flux Med: Robert Watts, Obra Grafica 1987," Joan Guaita, Estudi d'art Contemporani, Madrid

1977 "Cloud Music," San Francisco Art Institute (in collaboration with Bob Diamond and David Behrman); "Oraculum," Studio Morra, Naples, Italy

1975 "Signatures in Neon: Old and New Masters," Multhipla, Milan, Italy

1973 "Auto Series," La Bertesca, Milan, Italy; "Retrospective Exhibition," Galerie Baecker, Bochum, West Germany

1971 "Addendum to Pop," Apple Gallery, New York City

1968 "Neon: Objekte, Skulpturen," Ricke Gallery, Cologne, West Germany

1966 "Three Environments and Objects," Bianchini Gallery, New York City; "Neons and Objects," Ricke Gallery, Kassel, West Germany

1962 "Constructions, Objects, Events and Games," Grand Central Moderns, New York City

1958 Delacorte Gallery, New York City

1957 Douglass College, Rutgers University, New Brunswick, New Jersey

SELECTED GROUP EXHIBITIONS AND PERFORMANCES
1990 "Exotism," Ezra and Cecile Zilkha Gallery, Center for the Arts, Wesleyan University, Middletown, Connecticut; "Biennale of Sydney," Australia; "Venice Biennale," Italy; "Fluxus," Gallery 360, Tokyo; "Fluxus: Beuys-Cage-Brecht-Filliou-Macuinas-Knowles-Kopcke-Vautier-Watts-Williams," Yuill Crowley Gallery, Sydney, Australia

1989 "Fluxus: Moment and Continuum," Stux Gallery, New York City; "Happenings & Fluxus," Galerie 1900-2000, Galerie de Poche and Galerie du Genie, Paris; "Image World: Art and Media Culture," Whitney Museum of American Art, New York City

1988 "FluxLux, The Last Event of Robert Watts," (memorial events after artist's score), Martin's Creek, Pennsylvania; "Fluxus: Selections from the Gilbert and Lila Silverman Collection," The Museum of Modern Art, New York City (traveling exhibition); "Fluxus and Friends," The University of Iowa Museum of Art, Iowa City

1987 "Made in U.S.A.: An Americanization in Modern Art, The '50s & '60s," University Art Museum, University of California, Berkeley

1985 "Festival of Fanatics," Galerie Sct. Agnes, Roskilde, Denmark; "Artists' Postage Stamps," Museum für Moderne Kunst, Wedel, West Germany

1984 "Blam! The Explosion of Pop, Minimalism, and Performance, 1958-64," Whitney Museum of American Art, New York City

1983 "Retool," Artisanspace, Fashion Institute of Technology, New York City

1981 "Fluxus etc.," Cranbrook Academy of Art Museum, Bloomfield Hills, Michigan; "Soundings," Neuberger Museum, State University of New York at Purchase

1979 "Re-visions," Whitney Museum of American Art, New York City; "International Mail Art," Véhicule Art, Montreal; "Flux Concert," The Kitchen, New York City

1978 "Private Images: Photographs by Sculptors," Los Angeles County Museum of Art; "Another Aspect of Pop Art," P.S. 1, Long Island City, New York

1975 "Language & Structure," Kensington Arts Center, Toronto; "Flux Harpsichord Recital," Anthology Film Archives, New York City

1972 "Documenta 5," Museum Fridericianum, Kassel, West Germany; "Bread Festival," Deson-Zaks Gallery, Chicago

1970 "Information," and "Photography Into Sculpture," The Museum of Modern Art, New York City

1968 "The Machine," The Museum of Modern Art, New York City

1966 "Electric Art," Ileana Sonnabend Gallery, Paris; "Games Without Rules," Fishbach Gallery, New York City; "Art Turned On," The Institute of Contemporary Art, Boston, and The Museum of Modern Art, New York City

1965 "Pop Art and the American Tradition," Milwaukee Art Center, Wisconsin

1964 "Introducing: Richard Artschwager, Christo, Alex Hay and Robert Watts," Leo Castelli Gallery, New York City; "Fluxus Performance," Carnegie Recital Hall, New York City

1963 "Biennale," Musée d'Art Moderne de la Ville de Paris; "Mixed Media and Pop Art," Albright-Knox Art Gallery, Buffalo, New York

1962-63 "Yam Festival," an International Event Series

1962 "Fluxus International Festival," United States, Canada, Europe, Japan

1961 "The Art of the Assemblage," The Museum of Modern Art, New York City; "Art in Motion," Moderna Museet, Stockholm, Sweden

1960 "New Forms, New Media II," Martha Jackson Gallery, New York City

NEIL WINOKUR

Born 1945, New York City

Resides New York City

SELECTED SOLO EXHIBITIONS
1992 Barbara Toll Fine Arts, New York City

1990 "Self-Portrait: An Installation," Janet Borden, Inc., New York City; "Object Portraits," Barbara Toll Fine Arts, New York City

1988 Barbara Toll Fine Arts, New York City

1986 "Totems," Barbara Toll Fine Arts, New York City

1985 "Face to Face," Museum of Art of Bahia, Salvador, Brazil

SELECTED GROUP EXHIBITIONS
1992 "Persona," Museum of Photographic Arts, San Diego, California

1991 "Pleasures and Terrors of Domestic Comfort," The Museum of Modern Art, New York City; "Past and Present: Photography from the Permanent Collection of The Museum of Fine Arts, Houston," The Museum of Fine Arts, Houston, Texas

1990 "Identities: Portraiture in Contemporary Photography," Philadelphia Art Alliance, Pennsylvania

1989 "The Photography of Invention: American Pictures of the 1980s," National Museum of American Art, Smithsonian Institution, Washington, D.C. (traveling exhibition)

1988 University of Massachusetts at Amherst; "The Dog Show," Jan Kesner Gallery, Los Angeles

1987 Baltimore Museum, Maryland; "Portrayals," International Center of Photography Midtown, New York City

1985 "Aqueous Chamber," Gallery Hirondelle, New York City; "Weird Beauty," The Palladium, New York City; "The Picture Show," Steven Adams Gallery, New York City; "Live Stills," DeFacto Art Salon, New York City; "Seduction," White Columns, New York City

1984 "Fotografische Portrat," Schwan & Boder, Düsseldorf, West Germany; "Photokina '84," Cologne, West Germany; "Four Portrait Photographers," Delahunty Gallery, Dallas; "Face to Face," Institute of Contemporary Art, University of Pennsylvania, Philadelphia; "Family of Man: 1955-84," P.S. 1, Long Island City, New York

1983 "Presentation: Recent Portrait Photography," The Taft Museum, Cincinnati, Ohio; "3 Dimensional Photography," Castelli Graphics, New York City

1982 "Faces Photographed: Contemporary Camera Images," The Grey Art Gallery and Study Center, New York University, New York City; "Lichtbildnisse: Das Portrat in der Fotografie," Rheinisches Landsmuseum, Bonn, West Germany

Special Collections: The Photographic Order From Pop to Now closely coincides with the 30th anniversary of the emergence of Pop Art, Fluxus and the monumental changes in the American and international art world that began three decades ago. The realization of any exhibition and publication covering such a extensive period of time and such a diverse selection of artists relies on the support, advice and assistance of countless individuals.

First and foremost, I must express my gratitude to all the artists for their assistance and extra efforts in helping me realize this exhibition. Without their cooperation this project would have been far more difficult, if not close to impossible.

While the ultimate success of this project must be given to a long list of people, I want to convey a very special note of appreciation and thanks to the collectors, galleries and museums for their generosity in making the artworks available for this exhibition: Anne and William Hokin; Carol and David Dorsky; James K. Patterson; Antonio Homem of Sonnabend Gallery, New York; Fred Hughes, Vincent Fremont, Sheila Littell, Paul Tucker and Jane Rubin of The Andy Warhol Foundation, New York; Robert Egleston and Martha Williams of The Capital Group Foundation, Los Angeles; Steve Smith of Continental Insurance, New York; Elisabeth Kirsch and Douglas Drake of Douglas Drake Gallery, New York; Tracy Williams of Galerie Crousel-Robelin Bama, Paris; Marian Goodman and Jill Sussman-Walla of Marian Goodman Gallery, New York; Douglas Walla and Anna Lundgren of Kent Gallery, Inc., New York; Lance Fung of Holly Solomon Gallery, New York; Larry Miller of Laurence Miller Gallery, New York; Barbara Moore of Bound & Unbound, New York; Carolyn Padwa of the New Britain Museum of American Art, Connecticut; Janet Borden of Janet Borden, Inc., New York; Rosamund Felsen of Rosamund Felsen Gallery, Los Angeles; Larry Miller and Sara Seagull of the Robert Watts Studio Archive, New York; Troy Maier of Barbara Gladstone Gallery, New York; Michael Solway of Carl Solway Gallery, Cincinnati; John Rudy of the Visual Studies Workshop, Rochester, New York; Michael Katchen of Franklin Furnace, New York; Tom Lyons and Friedrich Petzel of Metro Pictures, New York; Craig Krull of Turner/Krull Gallery, Los Angeles; Jones Troyer Fitzpatrick Gallery, Washington, D.C.; and Jay Gorney Modern Art, New York.

At the International Center of Photography I am extremely grateful to Buzz Hartshorn, Deputy Director for Programs, and Ann Doherty, Deputy Director for Development for their extra efforts at making *Special Collections* a reality. And also, to Cornell Capa, the Founding Director of ICP for his continued encouragement and support. A special thanks to the numerous staff members at ICP who helped bring this cooperative endeavor to fruition: Midge Lewin, Phyllis Levine, Steve Rooney, Marie Spiller, Dianne Simmonds, Marta Kuzma, Mimi Young, Chris Heindl, Robert Hubany, David Spear, Annie Fisher, and interns Barbara Nuddle, Frédéric Rossi, Mike Costanzo and Susan Metler. To Lisa Dirks for her organization of data for the timeline. To Art Presson for the design of this publication. And, I am particulary grateful to Paula Curtz, for her extraordinary assistance, outstanding hard work, and painstaking attention to a seemingly endless number of details on all aspects of the exhibition and publication.

For their invaluable recommendations, suggestions and conversations, I am indebted to John Coplans, Peter MacGill, Janet Passehl, Jeannie Meyers, Mitchell Syrop, Douglas Huebler, Marilyn Zeitlin, Barbara Schaefer, Andrea Miller-Keller, Kim Davenport, Clive Philpot, Jim Sheldon, Martha Langford, Marvin Heiferman, Susan Solomon, and my father, Chuck Stainback. I want to thank Evelyn Roth for her editing of the initial drafts of the essay; and Amy Hughes for her important suggestions and tireless assistance while editing the final version of the essay. And most importantly to Joanne Ross and Max Stainback, for their patience, understanding and never ending encouragement, a very, very special thank you.

Finally, I need to express my appreciation to the New York State Council on the Arts, the Merlin Foundation and Christie Sherman for their generosity in awarding grants in support of the exhibition; to the Lannan Foundation for supporting the accompanying lecture series at ICP in the Fall of 1992; and to The Robert Mapplethorpe Foundation for their support of this catalogue.

C.S.